HOW TO TONE MANGA
TONING TECHNIQUES REVEALED!

Text, Toning and Layout:
Robby Bevard

Cover:
David Hutchison

Art Contributions:
Ben Dunn
David Hutchison

Editing:
Robert Acosta
Doug Dlin

Materials illustrations:
Sherard Jackson

HOW TO TONE MANGA

TONING TECHNIQUES REVEALED!

Author: Robby Bevard
Art Contributions: Robby Bevard, Ben Dunn and David Hutchison
Cover Design: David Hutchison
Layout: Robby Bevard

Editor in Chief - Jochen Weltjens
President of Sales and Marketing - Lee Duhig
Art Direction - Guru e-FX
VP of Production - Rod Espinosa
Publishing Manager - Robert Acosta
Managing Editor - Paul Kilpatrick
Publisher - Joe Dunn
Founder - Ben Dunn

How to Tone Manga: Toning Techniques Revealed
an Antarctic Press Production

Antarctic Press
7272 Wurzbach Suite 204, San Antonio, TX 78240

"So our heroes are trapped in a fully-functioning peanut processing plant that's on fire? That's just nutty."

ISBN: 1-932453-79-2

Printed and bound in Canada.

HOW TO TONE MANGA
TABLE OF CONTENTS

Chapter 1: Basics. .005

Chapter 2: Advanced Figure Rendering.022

Chapter 3: Textures. .055

Chapter 4: Effects. .090

Chapter 5: Start to Finish.127

Hi there!

I'm Robby Bevard, and over the last couple years I've been toning various Antarctic Press books, including Ben Dunn's *Ninja High School* and *Heaven Sent*, and Rod Espinosa and Craig Babiar's *I Hunt Monsters*. I've also assisted David Hutchison with toning his book *Dragon Arms*, which you will see a lot of in here, and I've done toning work on a wide variety of other projects as well.

It's really a pretty fun job to take finished black-and-white art and tone it, to flesh out a picture and make it look better. There's a lot of nuances to toning as well. So when it came up in the office that we should do a book on "How to Tone," I jumped at the chance to share the knowledge I've learned from toning so many books. David Hutchison was really keen to work on this as well. Some of the stuff he figured out while working on *Dragon Arms* is amazing, and he wanted to share that. Over the course of this book, we're going to try and teach you everything we can think of. Toning is a deceptively easy-looking craft. It may appear simple, but there's a lot to it!

Throughout these chapters, I'm going to take you step by step through some of the stuff I've done, including entire pages at a time, to try and really show off my thought process. There's often some experimentation and going back and forth. The right answer doesn't always come immediately. In fact, it usually doesn't! Hopefully, by showing you how I approach a wide variety of pages and elements, along with the trial and error involved, I'll help you be better able to approach toning your own work. It takes a bit of patience, but with a little work and practice, you can do great things! Let's get started, shall we?

-Robby Bevard

CHAPTER ONE: Basics

This first chapter is going to focus on the basic concepts of toning: the tools, the simple methods, and making sense of how just a few tones can represent an entire range of colors. Almost all manga use tones to some degree, and learning the material in here will go a long way towards improving the overall look of your art!

Screentoning can be used to make an already good image even better.

The drawing in Figure A is pretty sharp. The use of black and white makes for a pretty good image, but toning can make it better.

Figure B uses a light tone to help separate areas by giving them definition and adding shadows where a solid black would be inappropriate.

Figure C on the next page makes use of all three of my standby tones to create a very good sense of depth, light, and shadow. It also fully pops out the characters and gives a sense of color to various elements, despite only using a variety of greys.

Figure A

Figure B

1 Light grey 2 Mid grey 3 Dark grey

These are the three greys I use most often, and which are my trusted standbys. The labels of "light grey," "mid grey," and "dark grey" may not be entirely accurate, as lighter and darker tones can be made, but as they're what I'll be using throughout this book, that's what I'm going to call them. I'll make note if I'm using anything else.

Figure C

There are multiple ways to tone

No one particular way is better than any other; they all have their advantages and disadvantages. Throughout most of this book, I will be using digital screentone because that is my personal preference, but I will use flat tones from time to time to make it easier to see exact details. The techniques in this book apply to every method.

Flat tone

This tone is straightforward and done in the computer using any number of drawing programs, or by hand with markers.

ADVANTAGES:
-Easy to use and change elements
-Can make a wide range of different tones and effects with ease, including marker effects

DISADVANTAGES: -Does not look like real manga. Most manga uses screentone of some sort.

Screentone

This tone is made by using transparent adhesive sheets with dot patterns printed on them, overlaying them on the art, and then cutting away the excess.

ADVANTAGES:
-Real manga uses it in many styles
-Easiest method by which to etch and crosshatch details

DISADVANTAGES: -Can be messy and time-consuming to use
-Sheets can be expensive

Digital Screentone

This tone is done in the computer, but uses various files and methods to make it appear to be screentone.

ADVANTAGES:
-Easy to use and change elements during the toning process
-Looks like real manga

DISADVANTAGES: -Process to make into screentone can be time-consuming and results may vary in print.

Each of the examples above is a 10% grey tone, which is the standard used for the lightest tones. Any less than 10%, and the grey becomes hard to see. The advantages and disadvantages of each method remain the same no matter how dark a tone you're using.

Materials for Non-digital Toning

If you're working on a computer using an image-editing program, you're pretty much ready to go.

However, there are many advantages and reasons to do it the old-fashioned way using screentone sheets, so we're going to spend the next couple pages going over some manual basics, so you have some idea of how to tone by hand.

All the principles and techniques in this book can be applied to both screentone and computer toning methods. It's all about what works best for you.

There are a great many tools for cutting, holding and moving tone sheets around, and most of them can be found in any art shop. Scissors will NOT suffice; you need to be able to work with the image on the art, which calls for knives specifically designed for this kind of work.

X-Acto™ knives, one of the most commonly used brands, are fairly inexpensive and easy to find.

The actual screentone sheets are the most important part of screentoning by hand, obviously. They are transparent adhesive sheets with dot patterns printed on them. You overlay them on the art and then cut away the excess. Due to their adhesive nature and the cutting involved, they can be messy to use.

You'll also want a bottle of white ink handy, not just to cover up mistakes, but also to make some effects that would be difficult or impossible to create otherwise. You can use writing correction fluid as well, but it's not as suitable a consistency for this kind of work.

Basic Toning

Step one:
Put your finished illustration on a flat surface with good lighting. You'll need good light to help keep the picture clearly visible under the transparent sheets.

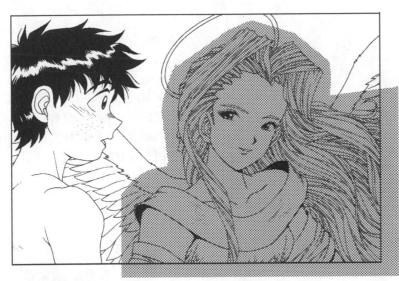

Step two:
Attach the tone, making sure it overlaps outside the areas you want it to cover when it is finished. In this case, I'm going to be shading the girl's hair and outfit.

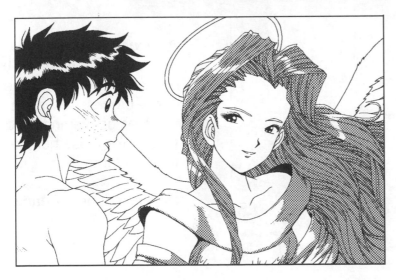

Step three:
Carefully cut the tone away from the places you don't want it to be. This includes white space around the hair and dress as well as lit-up areas, like the highlights in the hair.

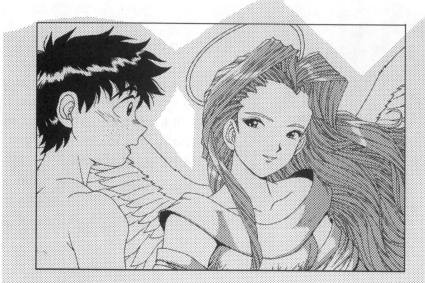

Step four:
Repeat the process using any other tones you want to put on the page, again cutting them away from areas where you don't want them, which includes areas where you've already placed tone.

(Overlapping tones will often cause moiré. More about moiré on page 17.)

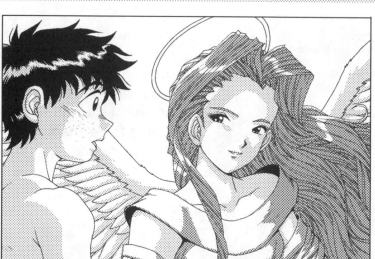

Step five:
Go in and use your X-Acto™ knife and/or white ink to clean up or fix any final details you may have overlooked or not thought of before now.

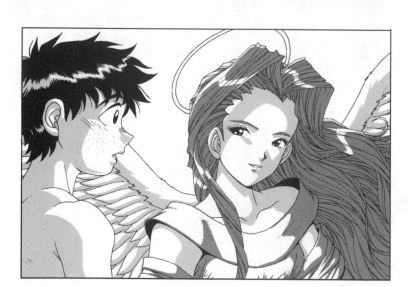

As you will see on the following pages, toning by computer is basically the same process, except it involves converting solid tones, like those here, to dot tone patterns.

How is it done? Read on...

How do I digitally screentone?

If you are doing screentone digitally, there are a couple of ways to go about it. The first is to drop in premade tones over the page and approach it exactly the same as regular screentoning, but that defeats the purpose of doing it digitally.

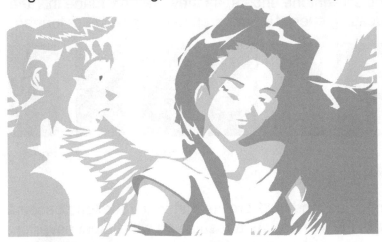

When you tone digitally, you can work underneath the line art by using a channel or layer separate from the line art.

With the line art off, the tones should look something like this. With the line art on, it should look like the last image on the previous page.

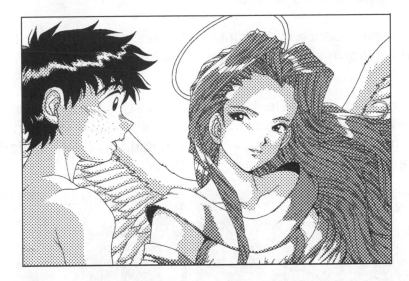

Digital screentone method one:

-Apply the line art so that the line art and grey are merged.
-Convert the image to bitmap using the "halftone screen" option. Use a dot frequency between 40 and 60 lines per inch.

This method is easier, but I don't recommend it. Minor differences in tone and dot frequency have unpredictable results.

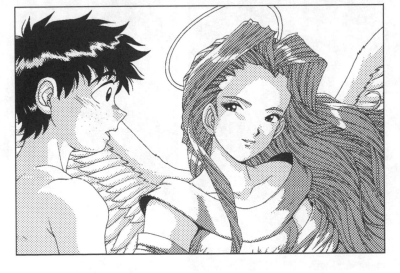

Digital screentone method two:

-Select areas that will have similar tone
-Paste in premade tones
-Apply the line art.

This is the method I use. I spent a lot of time making and testing screentones to get three values that I like and trust to print well.

Basic Tone Values

When toning, you have a wide range of values to choose from, from 0% grey, or pure white, up through 100% grey, which is pure black. However, as tempting and intimidating as that range is, you generally won't use minor degrees of difference, but instead larger increments of at least 10%. This is especially true when using screentone sheets, as they are only made in varieties of up to 50% grey. Below is a chart showcasing every 10% difference in the range of tones.

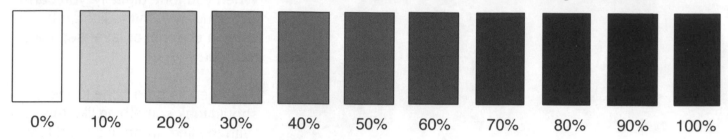

| 0% | 10% | 20% | 30% | 40% | 50% | 60% | 70% | 80% | 90% | 100% |

The reason screentone sheets aren't made beyond 50% grey is that, once the tone becomes too dark, it starts to blend in with and obscure the line art. As a result, you will almost never use a tone darker than 50%, or else you risk turning your picture to mud.

When toning, an important key is to achieve balance in the lights and darks, so that the eye isn't jarred by unbalanced shifts of tone and is drawn to the focal point of the image.

Figure A is unbalanced. It has far too much contrast, and it is difficult to tell where you are supposed to be looking.

Figure B has a consistent grey, but everything looks the same, making it difficult to focus because there is no contrast.

Figure C is balanced, and you can tell exactly where to look. A balance of light and dark has been achieved.

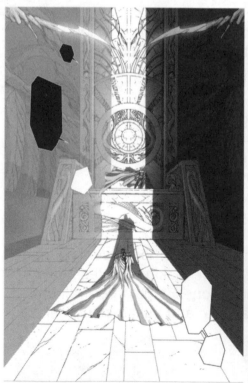

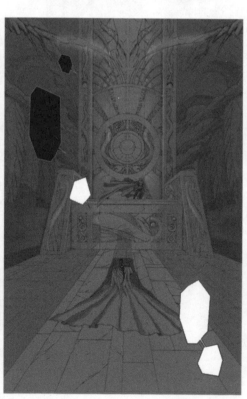

Figure A

Figure B

Figure C

Even though you have a wide variety of tones to choose from, when toning manga, in general you should try and keep it simple, using two tones at most. This is for reasons of both speed and clarity.

-The more tones you use, the more time you have to take to apply them.
-The more tones you use, the more confusing and messier the image may become.

Being conservative and smart with just a pair of tones will get you far. Two tones may not seem like a lot, but with the addition of black and white, that gives you four shades total to work with, which can be used in a variety of ways.

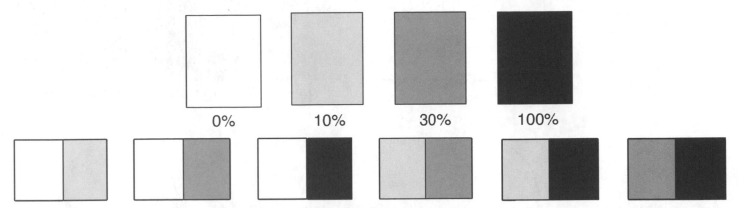

As you can see in the examples above, putting different tones together can seem to create more varieties of tone than are actually used. It's just a matter of being creative.

In the examples below, you can see how different use of tones can bring out different elements. Figure A uses mid grey in the background to pop out all characters, while figure B uses mid grey to pop the frontmost character forward, making him stand out. It's all about what you want the focus to be.

Figure A

Figure B

How can two tones create shapes?

If you're used to thinking in terms of color or typical rendering, the entire idea of using just two tones may be baffling. It's a concept I had a lot of trouble with at first, too, but it really is pretty simple and easy to get the hang of once you play with it for a while.

| 0% | 10% | 30% | 100% |

Classic rendering One-tone rendering Two-tone rendering Etching rendering

It boils down just to simplifying normal shading to its basic component shapes. By having an area of light and dark, you can still give the same basic impression of shape and form with a solid area of color. In chapter three, I'll show how you can etch in gradation to take toning a step even further, but for now, just concentrate on the principles of light and dark.

Figure A Figure B Figure C

When it comes to shadows, it is generally more effective if the shadow tone is darker than the tone of the object. Notice that while figure B has the most areas of different shades, figure C has the most pronounced and obvious sides and shadow. This is a matter of contrast, and it will come into play on more complex objects, like people and clothing. More tones over more areas is not always the way to go. Often, simple is best, hence the "two tones only" rule.

Hey, why's my picture blotchy?

So you've made your own screentone now or used a tried and true method, but for some reason, it looks funny.

Screentone, be it old-fashioned transparent sheets or done digitally, sometimes comes out with a blotched, checkered pattern when it is printed. This is called a **MOIRÉ PATTERN**, and it is a side effect of the printer not being capable of handling all the little dots screentones create.

Various causes for this include:
 -creating your own screentone at an odd size
 -bad photocopying or scanning of a screentoned page
 -overlapping two sets of tone
 -printer that just can't handle the job

Ways to avoid moiré include:
 -using nothing but tried and tested screentone patterns
 -not scaling files—changing their dimensions or proportions—after they have been screentoned
 -testing and retesting your own tone when you make it

There's not a lot you can do about moiré patterns when they happen. They crop up in professional work all the time. However, if they are occurring for you a lot, you may want to check what you're doing and try something different.

Also, if you see a moiré pattern while working on the computer, try zooming in or out on the image. Computer screens often can't display some dot tones at certain sizes, even if the tone is perfectly fine.

Tone Choices

When using only two tones for character rendering, it is important to try and strike a balance of tones, so that the characters have variety in their appearance. A lot of the time, a single tone can be used simply to convey shadows, but a second or third tone can go a long way towards making a character really stand out by providing balance.

Figure A is completely straightforward, with only one tone and no variety. It gets the job done, but Figures B and C are both much more defined and pleasing to the eye, because their tones make better balance. This makes it much easier to tell where the clothes end and the skin begins.

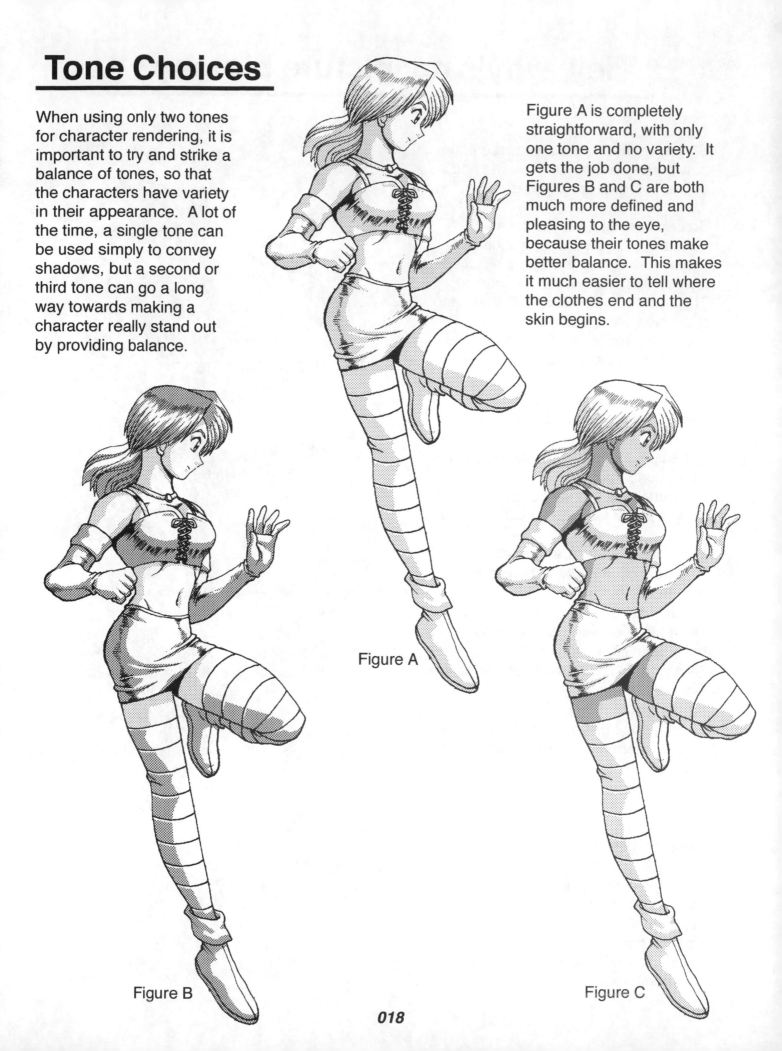

Figure A

Figure B

Figure C

Achieving balance with a character's coloration can be difficult, especially when you want to keep it simple and use only two tones. Just try and keep a variety of lights and darks throughout the characters to keep them interesting.

All three of these images are fairly balanced, with a range of lights and darks spread evenly. By using a creative mixture of just two tones as seen earlier, we appear to produce a wide variety of textures.

For example, placing light grey against mid grey seems to create a third tone (the shirts in Figures D and F, and the skintone and pants in Figure E).

Also notice that mid grey against white creates a different effect than light grey against white. Compare the pants in all three examples and notice how all three look like different shades, even though only two tones were used.

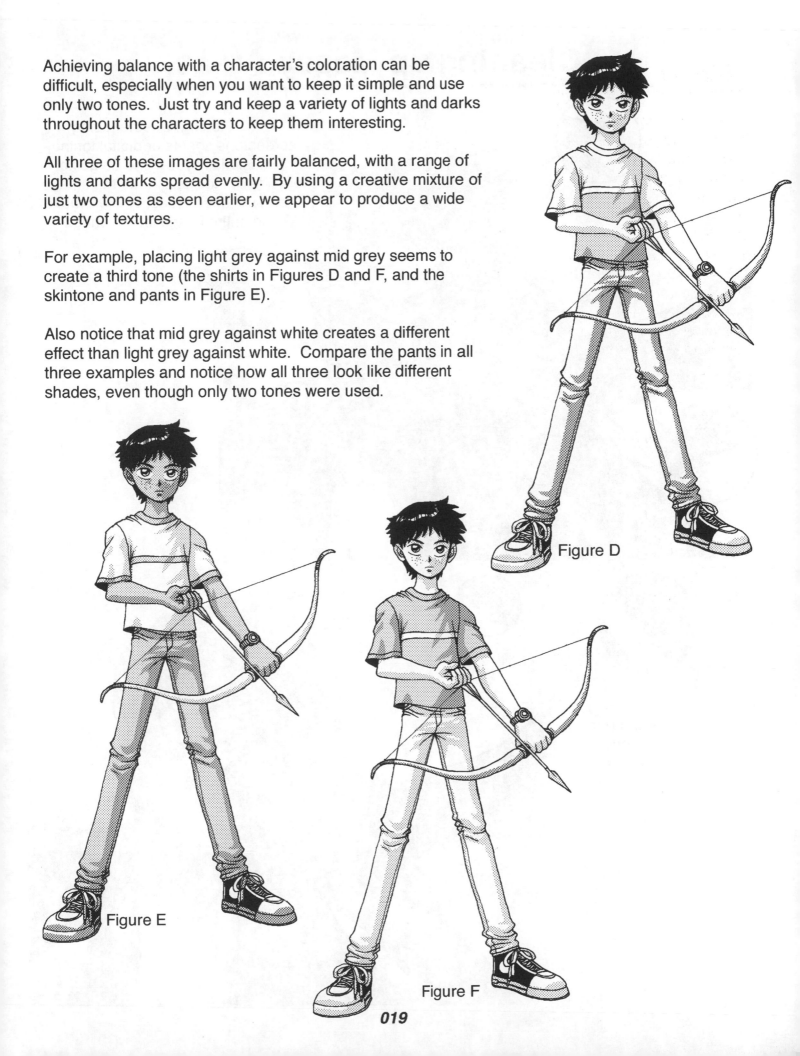

Figure D

Figure E

Figure F

Cleaning up Messy Areas

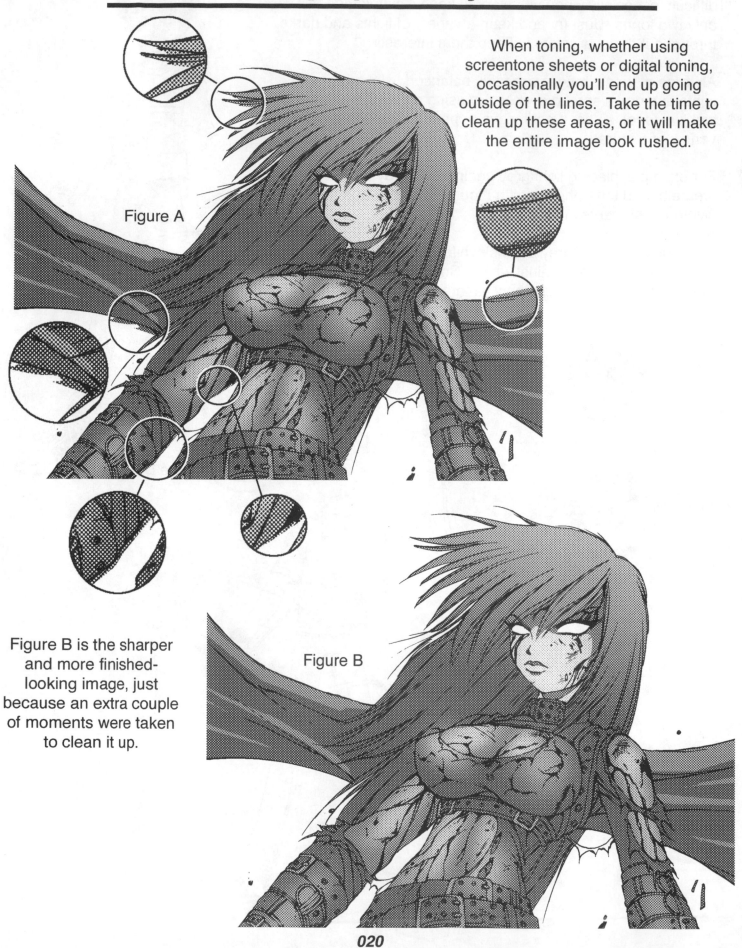

When toning, whether using screentone sheets or digital toning, occasionally you'll end up going outside of the lines. Take the time to clean up these areas, or it will make the entire image look rushed.

Figure A

Figure B is the sharper and more finished-looking image, just because an extra couple of moments were taken to clean it up.

Figure B

There were a lot of important points in the last few pages, so I'll repeat them. These are some very important elements to toning, so always try to remember these rules.

-IF YOU ARE USING TONES DARKER THAN 50% GREY, YOU MAY OBSCURE THE LINE ART.

-ACHIEVE A BALANCE OF LIGHTS AND DARKS.

-YOUR MAIN OBJECTIVE IS TO DRAW THE EYE TO THE PRIMARY POINT OF INTEREST.

-TRY AND KEEP IT SIMPLE, WITH TWO TONES AT MOST.

-SHADOWS ARE MORE EFFECTIVE WHEN THEY ARE DARKER THAN THE OBJECT.

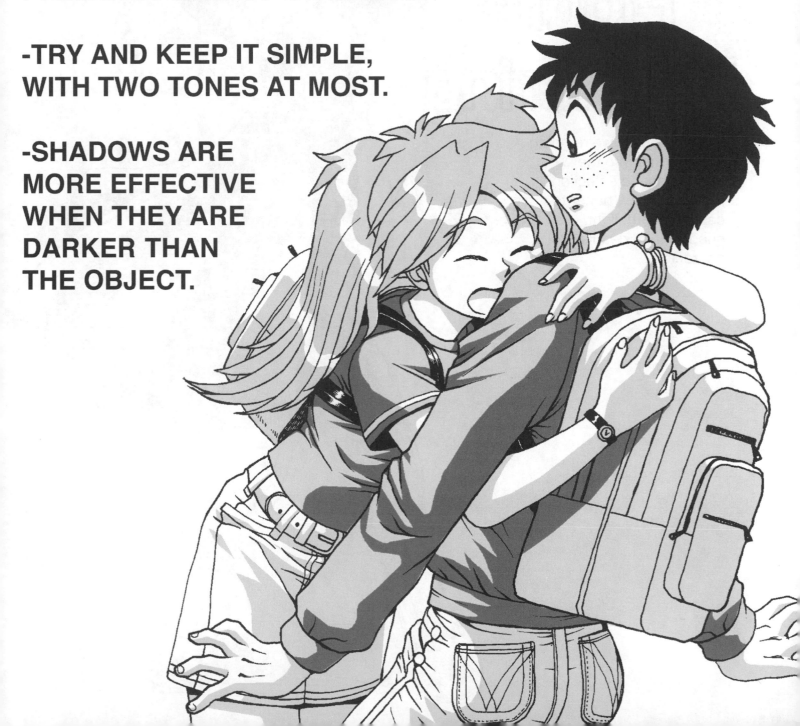

CHAPTER TWO: Advanced Figure Rendering

In this chapter, we're going to go further into the specific shape selections made and how better to convey depth, light, shadow, and details on characters.

Complexities of Form and Technique

Figure A

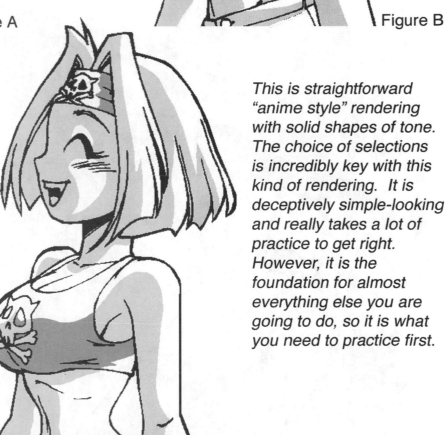

Figure B

Figure C

Rendering the female figure is one the trickiest parts to toning, because all the curves require an accurate knowledge of anatomy. The amount of shadow and highlight you place on them, as well as the amount of shadow cast by other parts of the body, will drastically change their appearance.

Figures A and B both place too much highlight on the chest, and have awkward shadows, making her look disproportionate. Figure C has the right amount of light and shadow, so the character looks more in proportion and natural.

This is straightforward "anime style" rendering with solid shapes of tone. The choice of selections is incredibly key with this kind of rendering. It is deceptively simple-looking and really takes a lot of practice to get right. However, it is the foundation for almost everything else you are going to do, so it is what you need to practice first.

Notice that because the pictures are being lit from different sides, the shadows are NOT the same shapes on both. Muscle mass, bone structure, and shadows being cast by the head, hair, and accessories all influence how the shadows will fall. You'll have to understand anatomy at least a little to get it right.

Figure A has a slight indentation on the stomach to indicate a rib cage, and both figures have different shadow shapes being cast by the head and breasts. It's all about the lighting and trying to simulate depth and roundness.

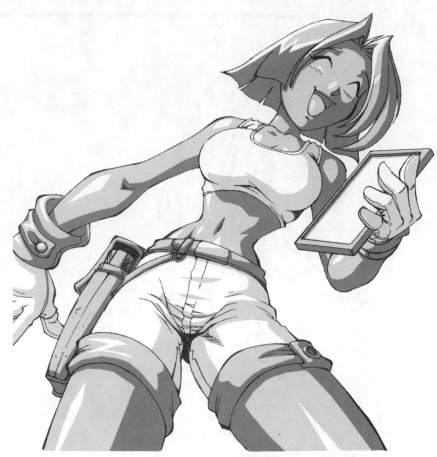

Figure A

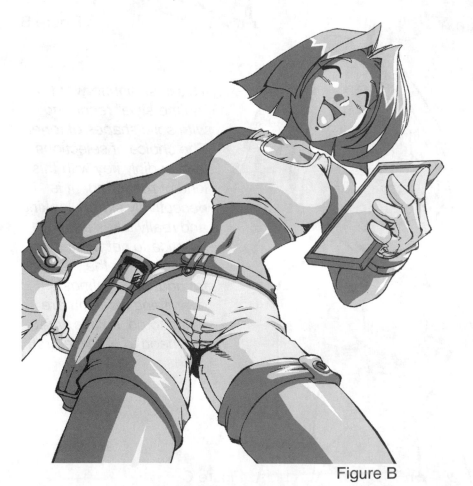

Figure B

This is advanced "anime style" toning. Using a darker set of tones on a character allows you to put in highlights. As you can see, the shape and size of the highlights change to represent the size or texture of the thing they are highlighting, and get smaller the further away from the light they are. Thin highlights are an option available to you when you tone a darker-skinned character or in specific lighting situations.

In real life, there is almost never complete shadow on any object. There is usually a subtle amount of secondary light reflecting off various things, which leads to the darkest part of the shadow actually being in the middle of the object, not at the edge.

This can be represented in toning by using **tone cuts**, thin dark areas of tone between the white and the light tone.

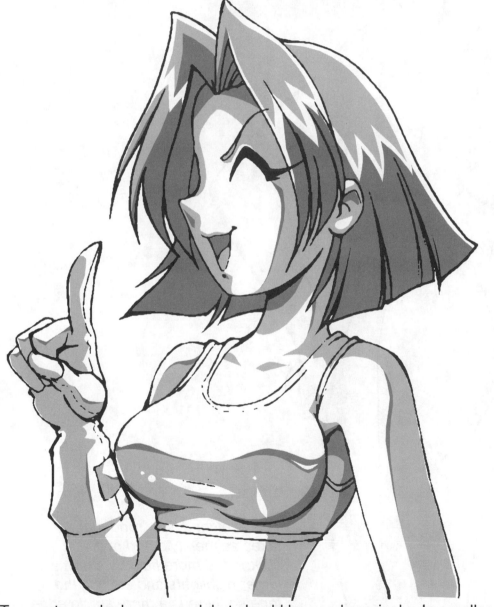

When used properly, tone cuts can help define an image and pop out the highlights.

Tone cuts can look very good, but should be used sparingly. In smaller images, the detail is almost completely lost, especially when using screentone. Tone cuts are also very tricky to render correctly because they are curved a specific way, so it is very easy to overdo them. Tone cuts are best saved for extreme lighting situations or for shiny, reflective objects.

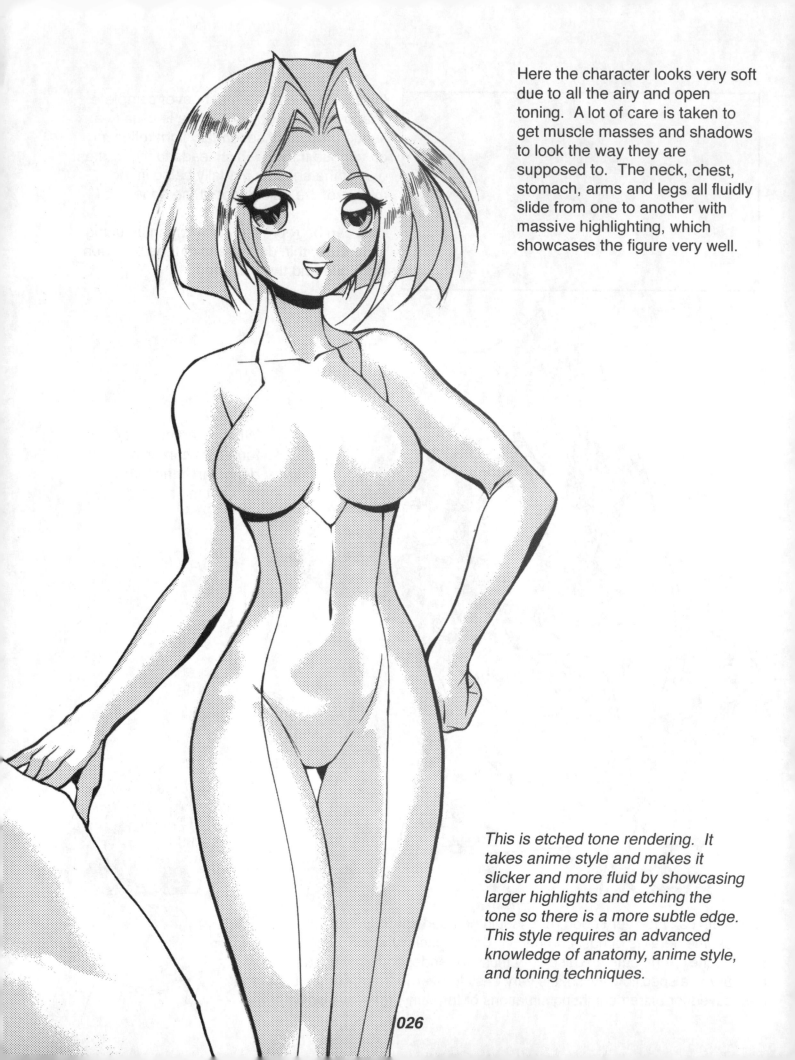

Here the character looks very soft due to all the airy and open toning. A lot of care is taken to get muscle masses and shadows to look the way they are supposed to. The neck, chest, stomach, arms and legs all fluidly slide from one to another with massive highlighting, which showcases the figure very well.

This is etched tone rendering. It takes anime style and makes it slicker and more fluid by showcasing larger highlights and etching the tone so there is a more subtle edge. This style requires an advanced knowledge of anatomy, anime style, and toning techniques.

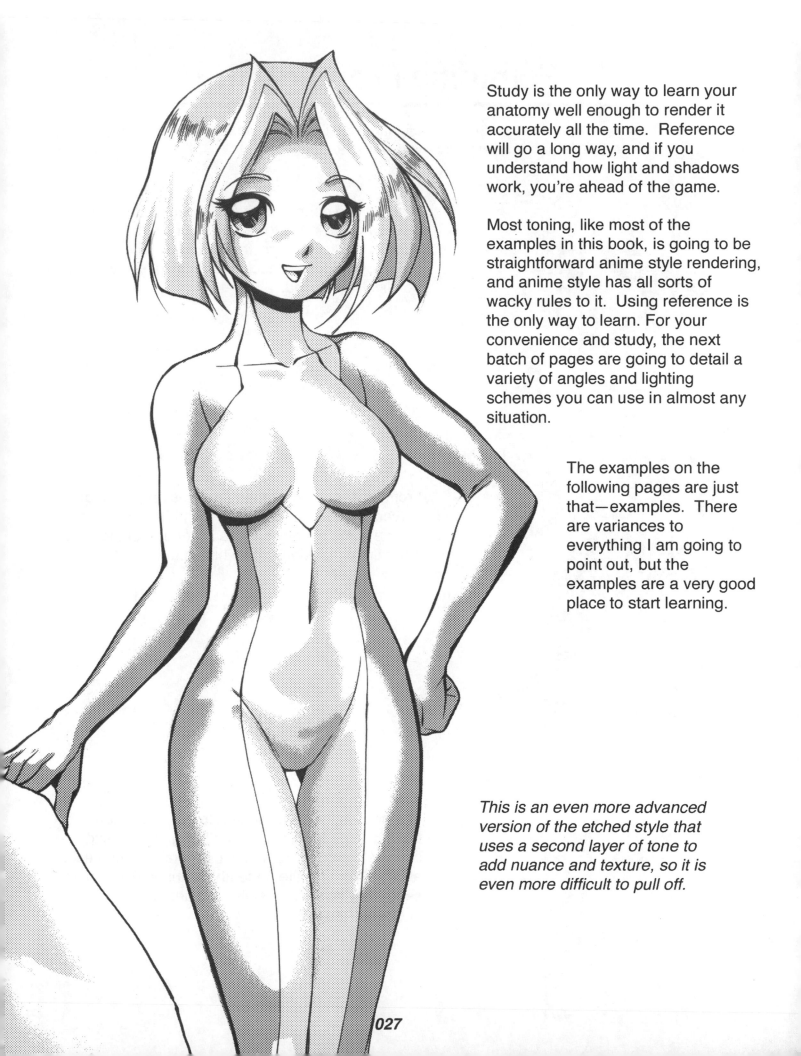

Study is the only way to learn your anatomy well enough to render it accurately all the time. Reference will go a long way, and if you understand how light and shadows work, you're ahead of the game.

Most toning, like most of the examples in this book, is going to be straightforward anime style rendering, and anime style has all sorts of wacky rules to it. Using reference is the only way to learn. For your convenience and study, the next batch of pages are going to detail a variety of angles and lighting schemes you can use in almost any situation.

The examples on the following pages are just that—examples. There are variances to everything I am going to point out, but the examples are a very good place to start learning.

This is an even more advanced version of the etched style that uses a second layer of tone to add nuance and texture, so it is even more difficult to pull off.

Feminine Frontlighting

Frontlighting is the most common lighting you'll use. In most situations, this will be the default and will serve you well in toning.

Frontlighting directly on a face doesn't create a lot of shadows, just in the lower areas of the hair. With the right art style, you can often get away with toning just a shadow under the neck and nothing else at all when frontlighting is used.

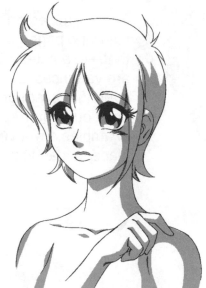

From an angle, frontlighting creates only a minor curved shadow on the cheek to indicate depth, and maybe some shadows in the lower part of the hair. The third dimension is only hinted at.

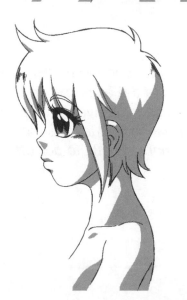

The nose is the trickiest area to get right when frontlighting. It will usually be just a small triangle to indicate a shadow beneath it. There will often even be a little sliver of white beneath the triangle to hint at secondary lighting, nostrils, and depth of the nose, all in a simplified style.

Feminine 3/4 Side-lighting

Frontlighting is used so frequently that the 3/4 lighting angle has been developed as an artistic alternative. Mastering the minor changes created by this lighting shift will go a long way towards creating variety in otherwise static sequences.

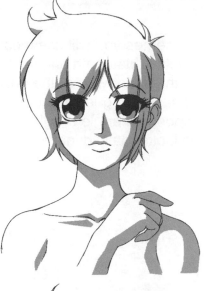

The biggest difference between this lighting and front-lighting lies in the nose and cheeks. The nose casts a longer shadow and the cheekbones might be more defined. It is really a matter of personal choice; you can keep the cheek smooth if you want.

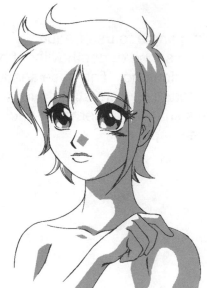

At this angle, the nose does not always cast the same shape of shadow as it does straight on. It can, but it looks better if it makes a psuedo-diamond shape, rounding out very slightly against the cheek.

When using this lighting, the nose shadow is not rendered in the exact same way in each view of the character, because it looks awkward.

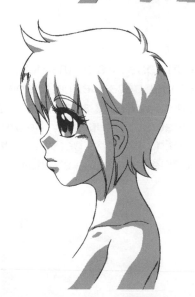

From the side, this lighting scheme isn't terribly appealing. The nose shape becomes awkward, the shadows from the lips are pronounced, and the cheek line can look strange. It is generally better to use one of the other lighting schemes when presented with a profile shot.

Feminine Side-lighting

Side-lighting is used mostly to add a sense of depth, because it causes the nose to cast a shadow across the face, which really contributes to making it appear three-dimensional. It is also more dramatic than front lighting, but should not be used all the time.

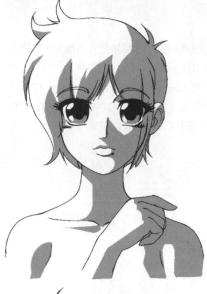

This is one of the lighting schemes you will use most often, because it so effectively adds depth and lighting to the figure, mostly due to the shadow from the nose. When the nose casts this shadow, it goes into the cheek shadow, creating almost a triangle of light on that side of the face, which looks really dynamic.

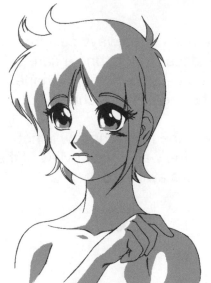

This is also a good lighting angle to use frequently, because it provides a good sense of depth without being too cluttered or unfeminine-looking. The nose shadow at this angle combines the shadows from straight forward and 3/4 angles, so there's shadow underneath and beside the nose to create shape.

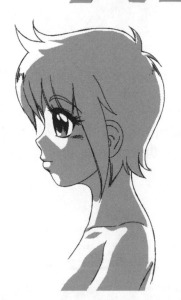

The shadows here very nearly obscure all the detail. Profile shots are tricky to render because the shape of the face limits what you can do with the shadows. You will almost never light a character up this way, because there are much more interesting ways to get nearly the same effect in profile. Also, the long nose shadow looks awkward from the side.

Feminine Backlighting

Backlighting is great for creating very dramatic shots or toning a character quickly. However, it tends to obscure the character and sap the detail out of the image. Backlighting is probably used to greatest effect if a character has glowing eyes.

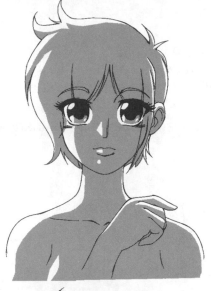

The only light visible on the character from this view is edge light. You can choose which side and how extreme to make the edge lighting, but it is most convincing when it is not exactly the same on both sides of the character.

You can also vary up how many highlights appear or not light the nose or lips at all, letting the face just fall into total shadow.

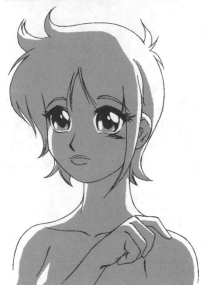

Depending on a character's haircut, a great deal of light might be visible when they are being backlit at this angle, but the face will be almost completely obscured.

I personally prefer to leave a character's eyes without tone so that they pop out and you can better see their expression, despite the lighting, but that is a style choice and is totally up to you.

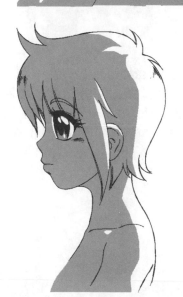

If you are trying to cover a character in dramatic shadow when in profile, this is probably the most effective lighting for it, because it lacks the weird shapes of side-lighting but allows for unique and interesting shapes in the hair.

Feminine Overhead Lighting

Straight overhead lighting is a more dramatic version of front lighting and can be used for occasional variety. Because overhead lighting is a more extreme lighting scheme, it should be saved for situations that have a more defined light source.

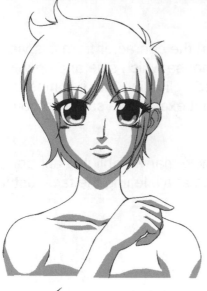

This light is very similar to frontlight. The big difference is that the edges of the figure fall in shadow almost equally, as opposed to the shadow dominating one side. Also, the nose creates no shadow to the side, but instead just a small triangle beneath it.

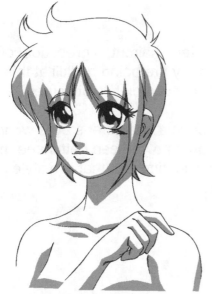

From this angle, the differences between overhead lighting and frontlighting are negligible. Lighting at this angle does round out the face a little more, however, and allows for different kinds of shadows on the body.

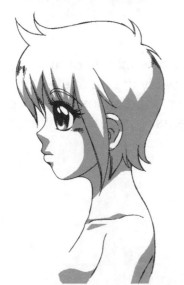

From this angle, the nose shadow is at its most interesting, for it is creating shadow directly underneath the nose instead of to the side of it. Also, because the arm is going slightly forward, the lighting on it is clean and simple.

Feminine Underlighting

Underlighting is very rarely used and is difficult to do because the shadows are so different from every other lighting angle. Underlighting is best used for scenes of characters magically transforming or to create an unusual and eerie atmosphere.

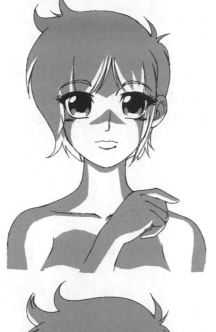

Extreme shadows are created by this type of lighting. The hair is left almost entirely in the dark except for bottom edgelighting, and the chest casts unique shadows that won't occur with any other lighting.

There is still a minor bit of shadow under the chin due to its angle, but the shadow isn't nearly as large as it usually is.

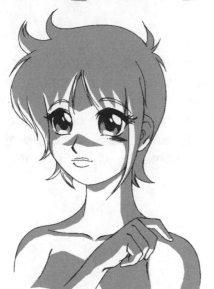

Normally the brow ridge creates a shadow over the eyes, but with this lighting, that area is lit up instead, and the shadow is on the forehead. The nose shadow is a sort of flat, upside-down V. This represents the shadow made by the nose ridge, cheeks, and eye sockets all in simplified manga form, and it is kept simple so that the girl can continue to look attractive.

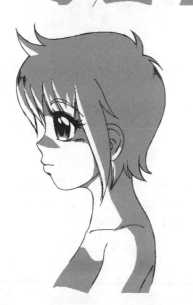

Another unique thing about this lighting is that between the unusual nose shadow and lit-up brow ridges, the eyes are surrounded by light, which really makes them pop out more than usual. With proper use, this lighting scheme could be used to focus on a character's expressions, though it is challenging.

Masculine Frontlighting

Frontlighting is the standard for men just like it is for women, but isn't used quite as much as it is with females. This is because males tend to look better with some of the other lighting schemes, as they generally have stronger noses and cheekbones than women.

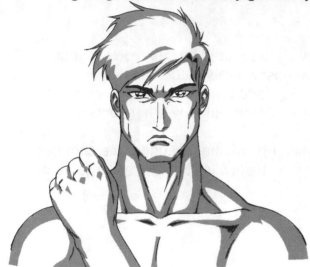

Notice on guys, the brows consistently drop heavy shadows, as do the cheekbones. The muscles on the neck also have very prominent highlights, but all told, this lighting is not the ideal for men, as it creates a number of odd shapes in the shadows that are strange to look at.

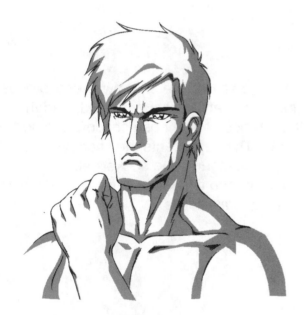

The furrowed brow creates a shadow that helps emphasize it, and the nose creates a complete shadow all the way up to the bridge. These are both elements that are much smaller or nonexistent on a woman's face. A man's face is typically rendered with more pronounced, angled features than a woman's, which is kept simple and smooth.

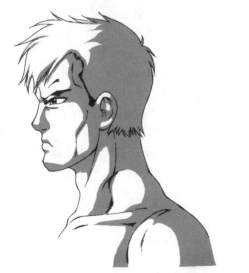

In almost all circumstances, from any angle, the male figure's chin will create a pronounced undershadow. This helps show that it is jutting out and three-dimensional, even if the chin is not drawn in a particularly pronounced fashion.

This lighting also creates a small shadow off the cheekbone, but leaves the light hitting the entire face, really showcasing the facial structure.

Masculine 3/4 Side-lighting

A slight variation on frontlighting, this serves men a little better because it allows for stronger variations of shadows and plays better with the defined cheekbones.

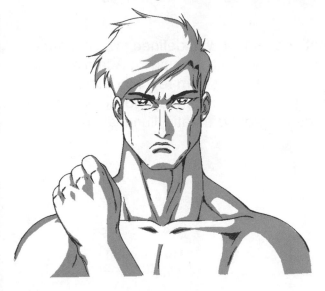

This is probably the best default lighting for men from the front. The very defined shadow along one side of the face that follows the cheekbone is a great visual, and this lighting also allows you to create a multitude of different nose-shadow shapes by changing the lighting only slightly. You also have the option with this lighting to render the other cheek's shadow a little or not at all, and make a variety of shadows around the eyes. This lighting also gives a variety of shapes on all the muscle groups and is about the best to play with all around.

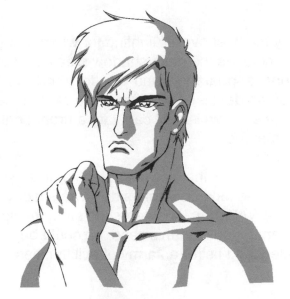

This light scheme isn't quite as effective on a slightly turned head, because it loses the contrast of the two sides of the face being shadowed differently.

The biggest advantage to lighting a man's face this way is that it still allows the ears and sides of the neck to be hit by light and provide some variety.

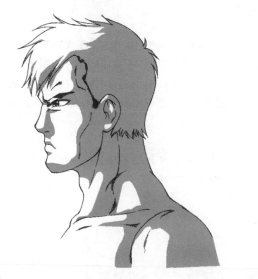

Profile shots can be made pretty effective with this lighting. Just enough light is hitting to create some full, rugged shadows and shapes.

In this example, I have included extra slivers of shadow under the cheek and above the lip to add definition and show how an extra well-placed shadow or two can make the character more rugged.

Masculine Side-lighting

Side-lighting creates very dynamic shadows on a guy's face, and you'll find yourself using it fairly often because it helps make the character look rugged and full of angles.

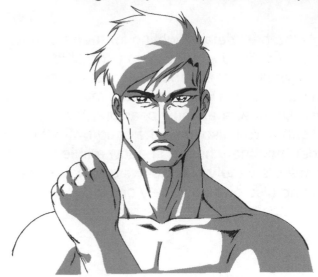

With a fully cast nose shadow, a defined jaw line, dark shadows around the eyes, and a bulging Adam's apple that is blocking all light from reaching half the neck, this lighting scheme can make a guy look really fierce and makes for great dramatic illumination.

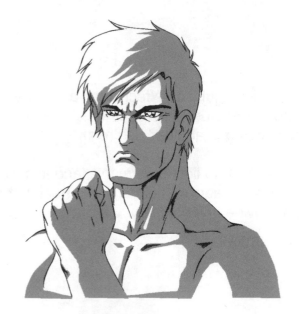

This is probably the best overall lighting for when a guy's head is at this angle, as the nose shadow creates a very three-dimensional appearance, and you don't have to deal with any of the details on the lit-up side of the face. How far the nose shadow is cast can vary a great deal according to preference.

Also, if you want to draw the viewer's attention in a direction, light up the face from that side. The shadow in this lighting lies AWAY from the interesting stuff; the light is where you want to look. In this case, he could be staring at his clenched fist or an army of evil flunkies behind him.

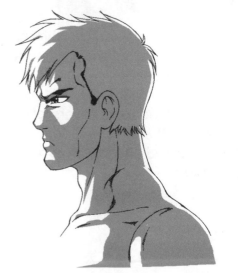

Side-lighting can be impressive against a man's profile. It can obscure enough details of the drawing that the character's mood and intent are hard to interpret, while letting just enough light hit the musculature to make the build impressive.

A sharp edgelight on the back is a strong extra touch that helps the figure pop even more.

Masculine Backlighting

Backlighting is great for showcasing a character that is mysterious, angry, or sinister. A man's body and facial structure lend well to it. However, the heavy shadows still obscure a character's face just like they do with women, so it is not a great option if you're trying to show emotion.

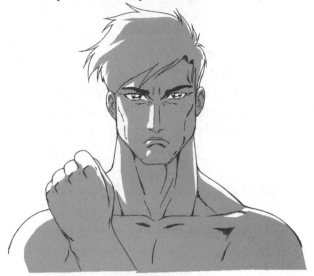

The strong edgelight following the sharp cheekbone, nose, arm and clenched fist gives just enough impression of form to show that the guy is intimidating. Little touches, like a bit of light hitting above the brow or on the chin, add even more depth.

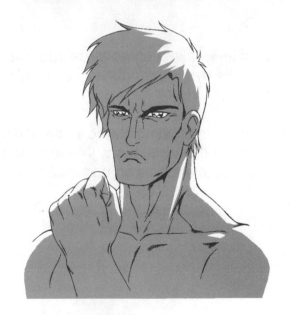

From this angle, backlighting obscures almost every detail of the character into shadow. Used properly, this can be very effective. However, I don't recommend using it very often, as it will lose its impact as a storytelling device.

If there are heavy blacks already indicating massive shadows on the character, or he has glowing eyes, those are the best times to make use of this near-silhouette.

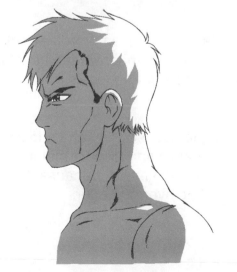

Backlighting a profile shot is a little more effective than on the above 3/4 perspective character because you can show a heavy amount of light on him, better indicating there's dramatic light involved. The same problems still apply, however. If you do this too often, the character will be obscured and hard to recognize.

Backlighting should be used sparingly for dramatic reveals or instances in which a character is angered and you want their expression to be unreadable.

Masculine Overhead Lighting

Overhead lighting played against a guy's cheekbones can lead to some really interesting shadows and shapes and can be used to focus strongly on his expression and eyes.

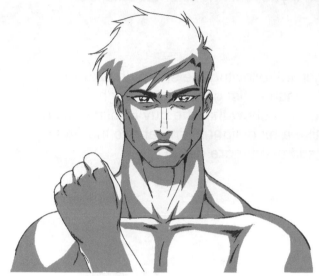

This lighting is far more effective on men than women due to the more pronounced cheek bones and jawbones and thicker necks. The shapes the light makes are very interesting and unusual and allow you to show off an angered hero while keeping his face well lit.

This lighting looks great in full-frontal shots like this.

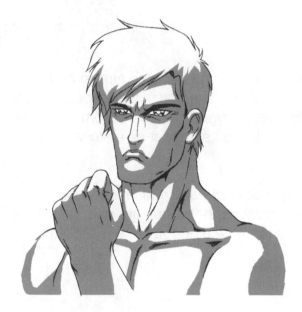

This lighting style is at its weakest on a 3/4-perspective head because it loses the dynamic symmetry a straight-on shot possesses.

However, it does allow for interesting shadows around the eyes and mouth that can be used to highlight them, and it really puts a spotlight on the expression under certain circumstances.

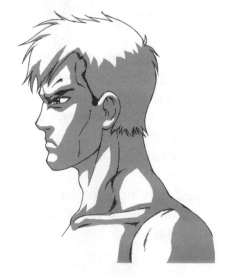

Overhead lighting looks pretty cool on a profile shot, because it puts a sharp, unique shadow on all the facial features while still highlighting the muscles in an interesting way.

This is a difficult lighting to use properly and should not be overused. It is so dynamic and distinct that it will very quickly become dull if used too much, because it is so obviously the same lighting over and over.

Masculine Underlighting

Underlighting is even trickier with men than it is with women due to the angles and muscles, but it looks really great for power-up-type sequences.

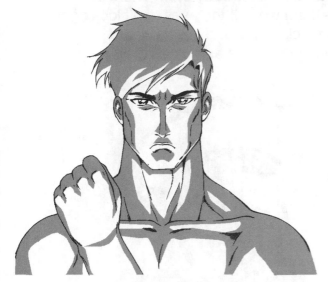

The chin, upper lip, and nose all cast shadows straight up and back when underlighting is involved, which leads to a nearly straight line of tone through the middle of the character's face. The sides are also left mostly in shadow, as strong cheekbones lead to that part of the face being indented and out of the way of the light.

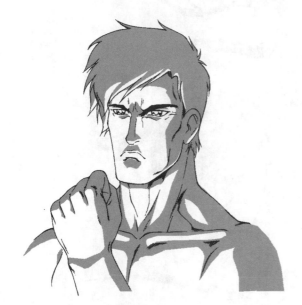

Note that there is a thin sliver of light along the bottom of the jawline, even though light goes no further. This is because the underside of the jaw is being lit somewhat by this light source, even if it doesn't show in most angles.

Be careful when lighting a male character like this, as it is really easy to make the character look as if he has a mustache or goatee, particularly if you're using a darker tone. This can be really jarring if there is no context to the lighting outside of one panel, and it could potentially confuse the viewer.

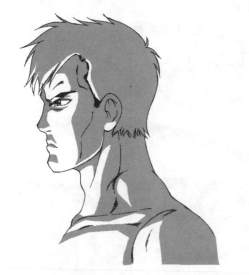

With the creepy lighting around the eyes and unusually defined features, it is difficult to keep a character from looking sinister in this lighting. If it is a heroic character, try and abstain from using this lighting for long unless their expression makes it clear they aren't the bad guy.

Of course, if the heroic character is really angry for some reason, exceptions can be made.

Grandma, what big eyes you have!

The eyes are the window to the soul, and this is especially true in manga. Eyes are usually very large and expressive, and convey more emotion than any other body part. There are many ways to tone them. The important thing is to tone them well. If the eyes don't look right, the entire character will look awkward. These are extreme closeups and are rendered accordingly. If the eye is small on the page, there should not be quite as much detail.

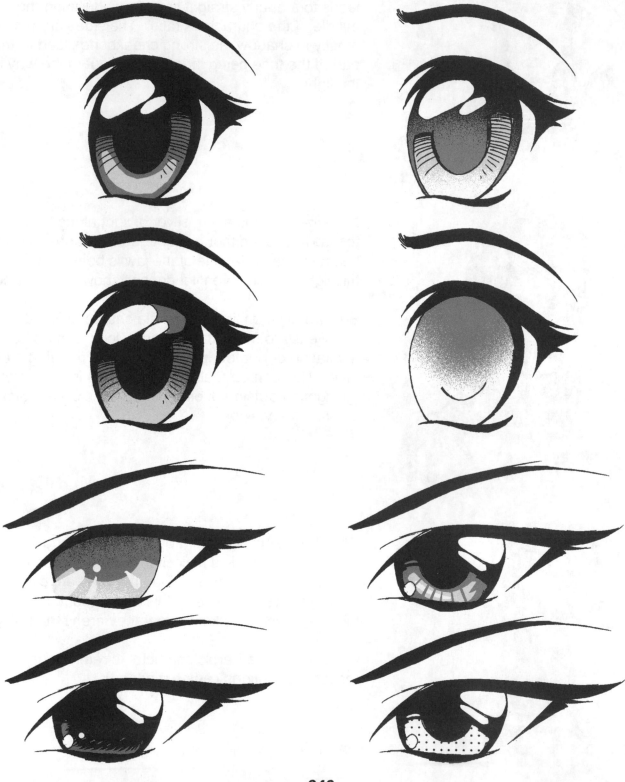

The eye is basically a reflective sphere, so keep that in mind when toning. The highlight reflections will pretty much always go to the outside of the eye. They won't appear in the dark center (the pupil) unless there is an extreme light source or a number of lights.

The more highlights an eye has, the cuter and more innocent it looks, perhaps because cute, innocent kids are known to be "wide-eyed."

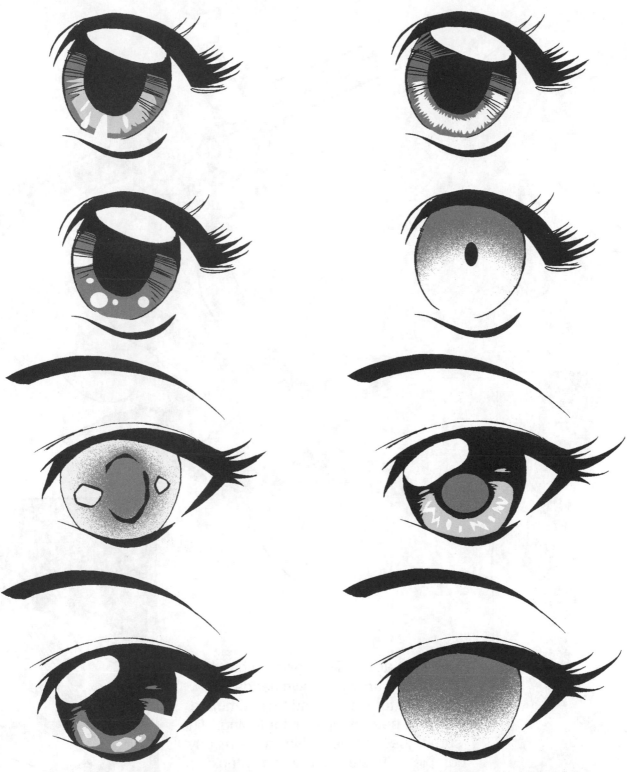

Notice when the pupil is very small, it seems to indicate primal fear or even insanity. When the eye is blank and devoid of detail, it indicates a lack of soul, which can be used to represent extreme shock or that the person is undead.

Hands

Hands are one of the most difficult things in toning. Because hands have so many bones and joints in them, they are extremely complex and difficult to shade accurately.

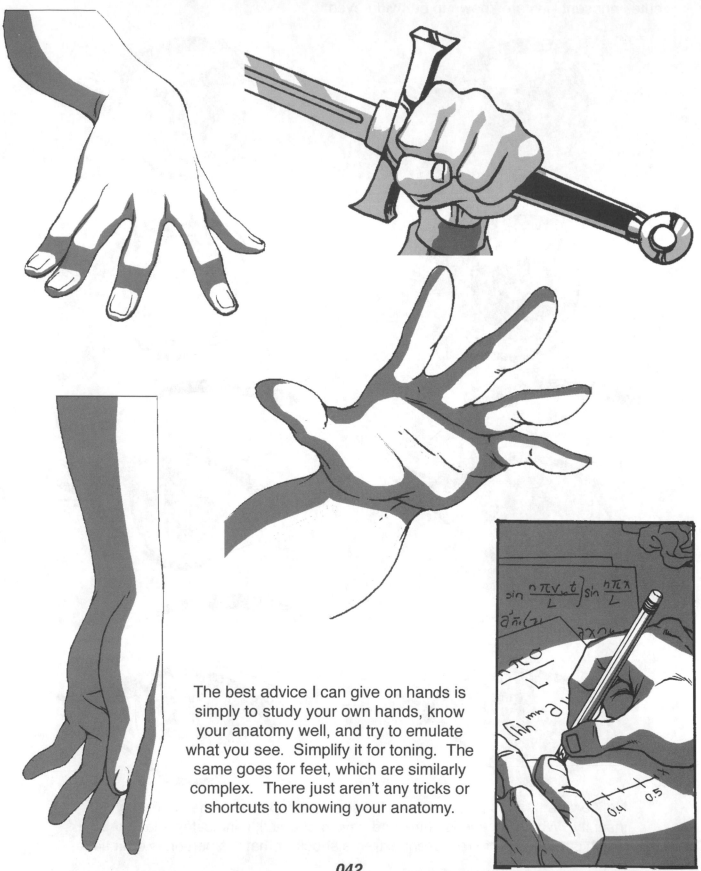

The best advice I can give on hands is simply to study your own hands, know your anatomy well, and try to emulate what you see. Simplify it for toning. The same goes for feet, which are similarly complex. There just aren't any tricks or shortcuts to knowing your anatomy.

Toning Large Crowds

Now that you've got the basic ideas about how to render characters, be warned: There will inevitably be situations in which you have to tone a LOT of characters, and that can be daunting. Don't be intimidated, however. If you take it easy, step by step, it isn't that hard at all. It's actually pretty fun when there's a lot of characters, because it gives you an opportunity to play around a little.

The first step is simply to lay down a light tone over all the areas that are going to have multiple tones. In this case, that includes all the clothes and the hair on all the guys.

You may have noticed that I went ahead and did the shading on the blond girl's hair, yet I didn't do her skin tone—or anyone else's, for that matter. That's because this is such a complicated piece, I'm doing the elements one step at a time. The skin tone will eventually be the same base tone that is on everything right now, but it will be easier to figure out those selections if they are all you're thinking about, as opposed to worrying about everything all at once.

Just take the faces one at a time, and think about what you're doing with each one. Don't worry about the large crowd, just concentrate on each face as its own entity.

Here I've gone in and added the darker tone for all the shadow areas, on both shirts and hair. Notice the skin tones still haven't been touched. That's next, and that's the fun part!

A general rule of lighting is that when there is no obvious light source, simply light from above. Large group shots are no exception, and that is for the best here. By lighting from above, it means every nuance or slightly tilted head gives you a new opportunity to try something different.

Notice how even though all four of these faces are in basically the same position and they're the same character, they're being shaded differently. Each has minor variances in the cheek shadow, the nose, around the eyes, even an occasional chin shadow! Just because there are basic rules of shadows doesn't mean you have to do things exactly the same every time.

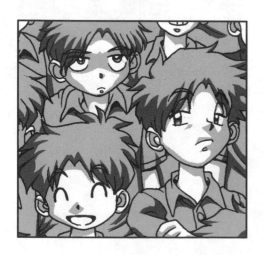

Of course, goofy expressions are even more fun to play with, because they're out of the ordinary. Take full advantage of a tilted head or weird mouth and have fun with it!

044

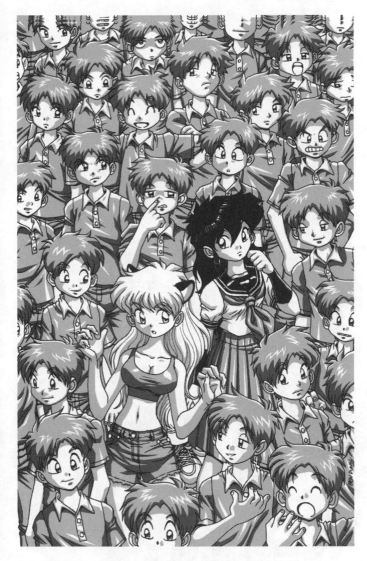

Try to keep the basic selection style similar. If one character's hair is radically different, with smooth highlights when everyone else has jagged ones, it will be jarring.

Now go in and add highlights! Just remove pieces from the areas of grey you've already put in to give bright spots to lighter parts of the clothing. I've done the shirt collars without any darker grey and with a lot of white, so they appear to be a totally different color from the rest of the shirt.

Doing highlights can be pretty fun, because it's basically the last step, so as you do the highlights, you get to see the image really coming together.

Try to keep the highlights in the middle of the light tone. Placing them too high up or too close to the shadow will look funny, especially when there's this many of them.

I also put a back edgelight on everyone as an extra step to try and help separate them from the characters behind them.

Even though the highlights are basically the same on everyone, observe how they differ depending on the angle of a character's head. Some go more up and down, others go more left and right, but there's always some zig-zag.

045

By simply taking it a step at a time, you've finished. All the characters are rendered now!

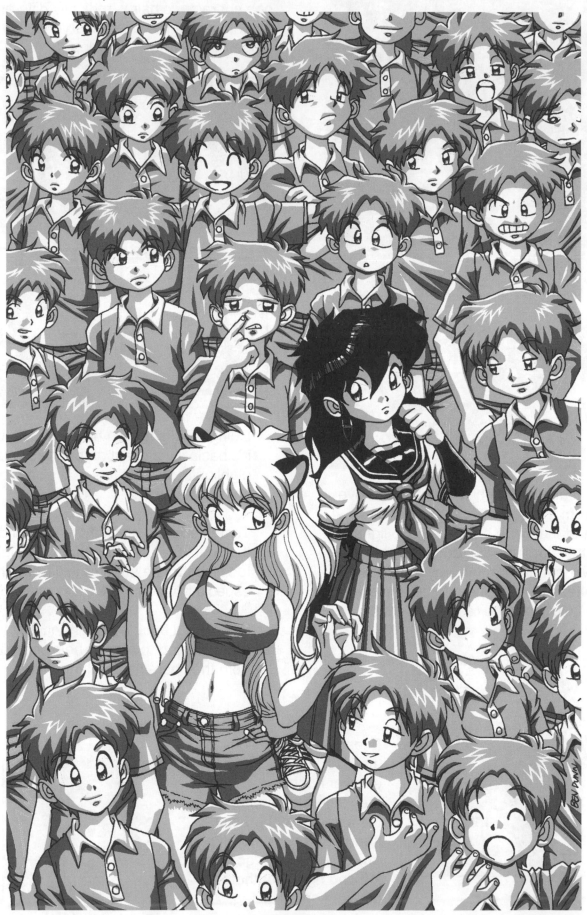

Choosing a Light Source

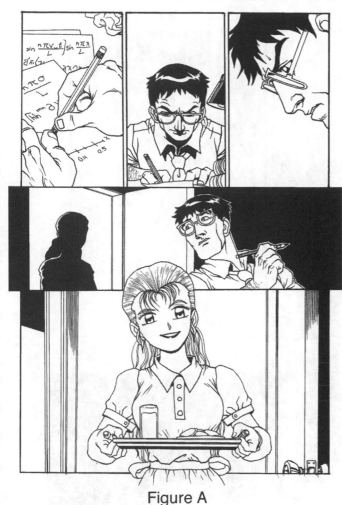

Figure A

Now that you've learned how to render characters from a number of different angles, you need to learn when and how to apply that knowledge. Every single time you tone a page, you're going to have to choose a light source. There's just no getting around it. A lot of times, you can simply use direct overhead lighting and be fine, because light sources are generally overhead, indoors or outside. However, if you do nothing but overhead lighting, it will very quickly become tedious for you to tone and for the viewer to look at.

Figure B is an example of a page toned normally with overhead light. It's a man working at his desk, only to be interrupted when his wife comes in—no big deal, and overhead lighting works just fine.

However, if you look at the page, the second panel has a lamp in it, and the fourth panel is very dark, with light coming from the doorway.

Both of these elements indicate that the scene might actually be at night, with the man working late hours in the mild lamplight. Those elements are an invitation to make the lighting more interesting!

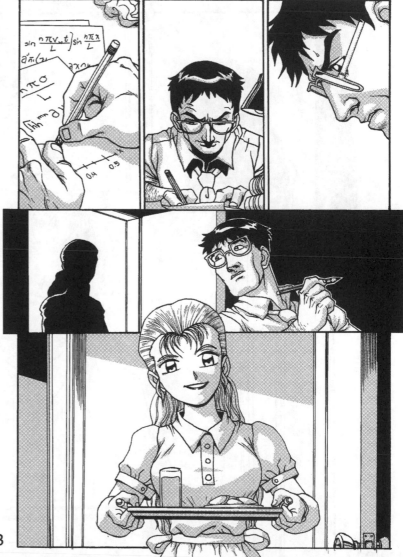

Figure B

This version of the page is much more interesting than the last. Using the lamp and the hallway light as specific light sources allows the creation of unique lighting that makes the page interesting. Take advantage of unique light sources when you spot them, because you can use straightforward overhead lighting at any time, but unique and interesting scenes are almost always better.

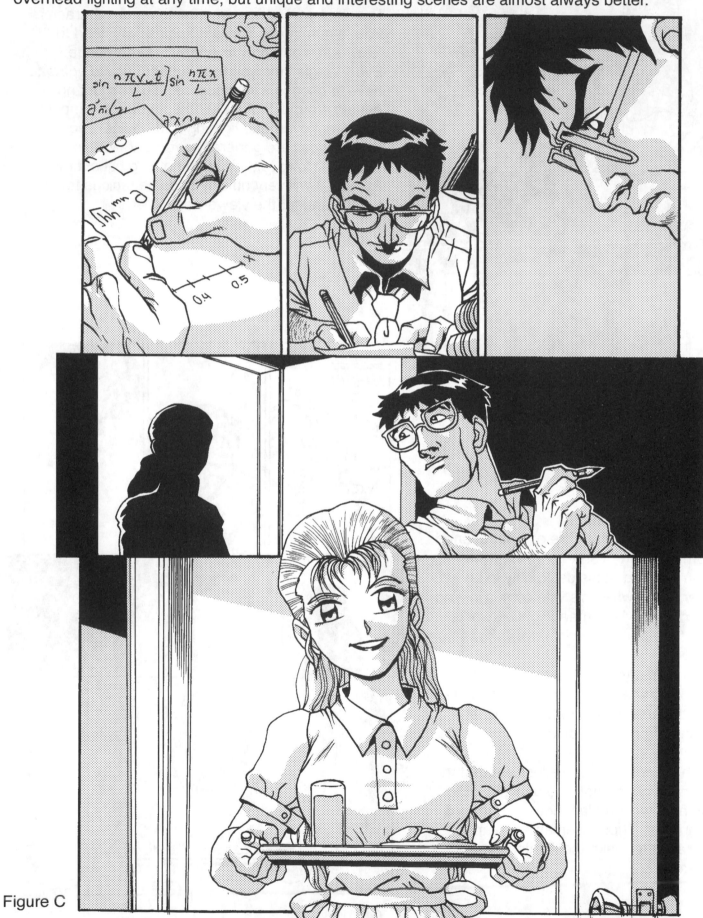

Figure C

Wings and Things!

Something that will often come up in manga is characters with feathered wings. There are a wide variety of ways to deal with wings and avoid the visuals becoming dull. The ideas presented here can be applied to almost anything, including capes, long hair, large weapons, ornate costumes, or anything else that has large, shadow casting sides or multiple small parts. Wings are just a great example because they showcase so many different ideas all at once.

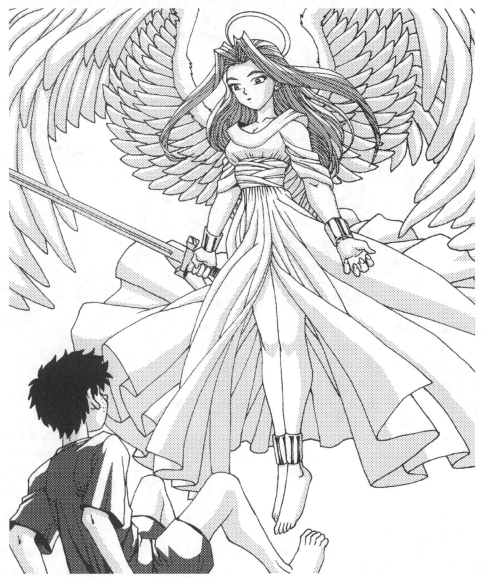

The big trick to feathered wings is just to follow their shape, keeping in mind that each feather will be casting a shadow on the feather below it.

In the left example, you can see that when feathers are laying flat and being lit from above, you have a fairly open white space with shadows that go around the edge.

In the right example, you can see that when feathers are on their sides, one way to light them is to highlight the top edges, showing the feathers are thin and flat.

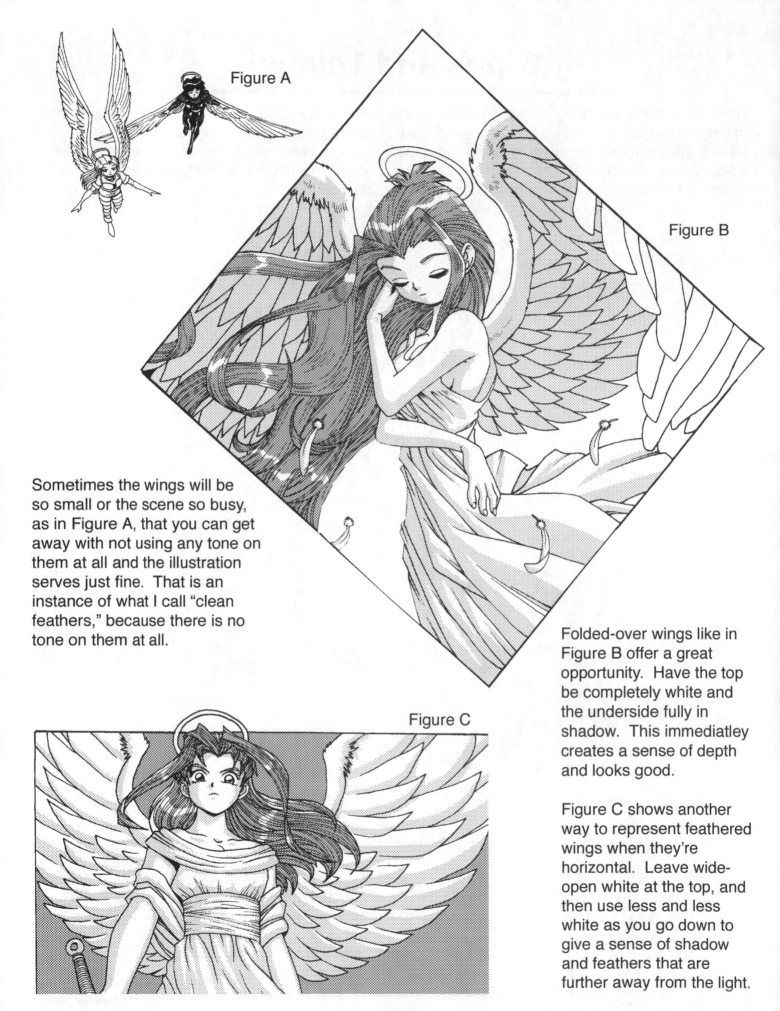

Figure A

Figure B

Sometimes the wings will be so small or the scene so busy, as in Figure A, that you can get away with not using any tone on them at all and the illustration serves just fine. That is an instance of what I call "clean feathers," because there is no tone on them at all.

Folded-over wings like in Figure B offer a great opportunity. Have the top be completely white and the underside fully in shadow. This immediatley creates a sense of depth and looks good.

Figure C

Figure C shows another way to represent feathered wings when they're horizontal. Leave wide-open white at the top, and then use less and less white as you go down to give a sense of shadow and feathers that are further away from the light.

The way you tone any set of wings is up to you. Figure A shows a fully rendered set of wings, while Figure B shows them in shadow. Both have their pros and cons.

Figure A showcases the wings, making their presence the main focus of the image. If the scene of an angel sitting between two characters is supposed to be awkward, then showcasing the unique feature is probably the way to go.

Figure B makes the wings less important and pops the characters forward. If there is going to be a lot of dialogue in the panel or you just want the focus to be on the faces, then pushing the wings back and making them less important is the way to go.

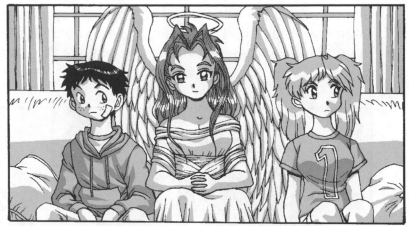

Figure A

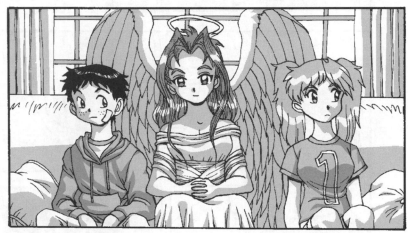

Figure B

In this particular case, there is a window behind the characters that is likely to be serving as the light source. So, the shadowed wings in figure B are probably the the right idea, because the light would not be hitting the feathers all that much.

Under certain circumstances, you can combine the two techniques, as seen in Figure C. If you have a definite light source coming from one side of a winged character, you can light up one side to show open, rendered wings. Then leave the other side in complete shade, creating a real sense of lighting and shadow.

Figure C

This is a sequence from a story. Notice how every sort of basic wing rendering is used to keep the page full of variety: fully open feathers, fully shadowed, clean, and then half-and-half. I'm not saying to do every trick you have on every page, but it is a good idea to try and avoid doing just one thing all the time.

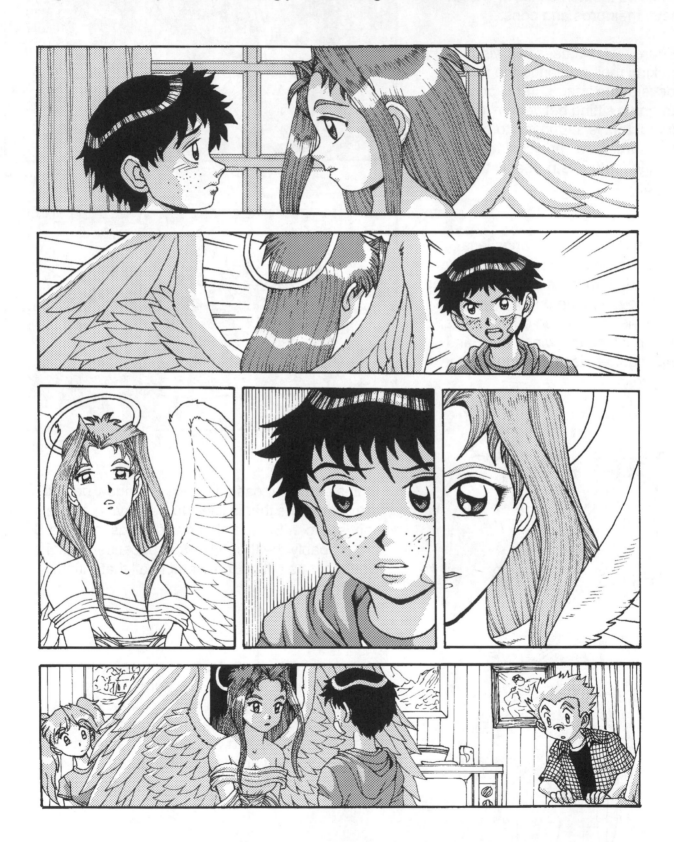

Generally, when toning feathered wings, you'll want to use a light tone to help enforce the impression they are light and soft. Sometimes, though, using a darker tone can create really dramatic moods. This works really well if you have each feather cast a shadow on the feather below it, because it leads to really sharp, interesting textures and shapes.

If you have several characters with feathered wings, you have to be careful to avoid confusion. Figure out what your focus is going to be and try to concentrate on that. In this instance, I pushed a character back by leaving her wings in shadow.

You can go all out when rendering wings, of course, giving texture, detail, and nuance to every single feather. However, this is VERY time-consuming, and if you're on any sort of deadline, it's probably unfeasible to go to this level of detail in every panel of every page. Also, if you did it on every page, it would soon stop being interesting and just be normal, and the amount of effort put into it would be taken for granted. Pick and choose your moments to really shine, and then give them all you've got.

CHAPTER THREE: Textures

Have you mastered the ideas and concepts from the early chapters, character shape selections and the rule of using only two tones?

Good.

Now you're ready to bend those rules a little, like using a third tone for texture!

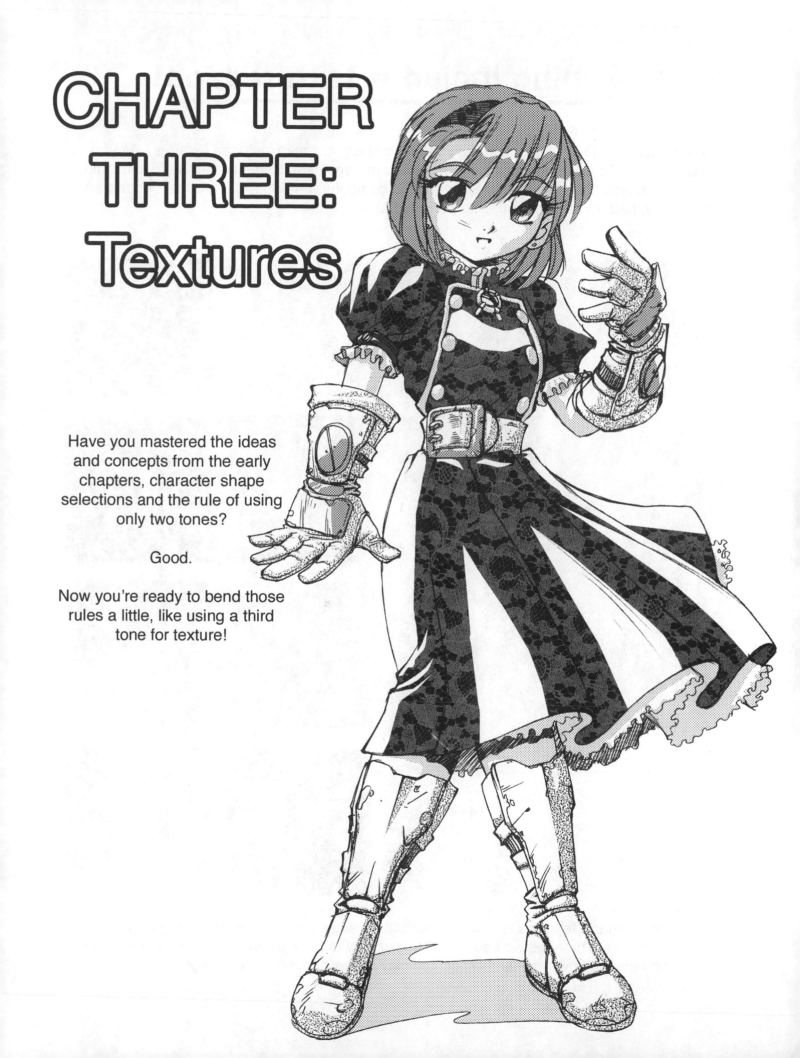

Toning includes textures too!

Toning isn't limited to just dropping in shades of color; it also includes textures. As you can see on this page, the texture possibilities are endless! Some patterns are available as screentone sheets, some are done in the computer, and others are done by hand and then scanned into the computer to be dropped in.

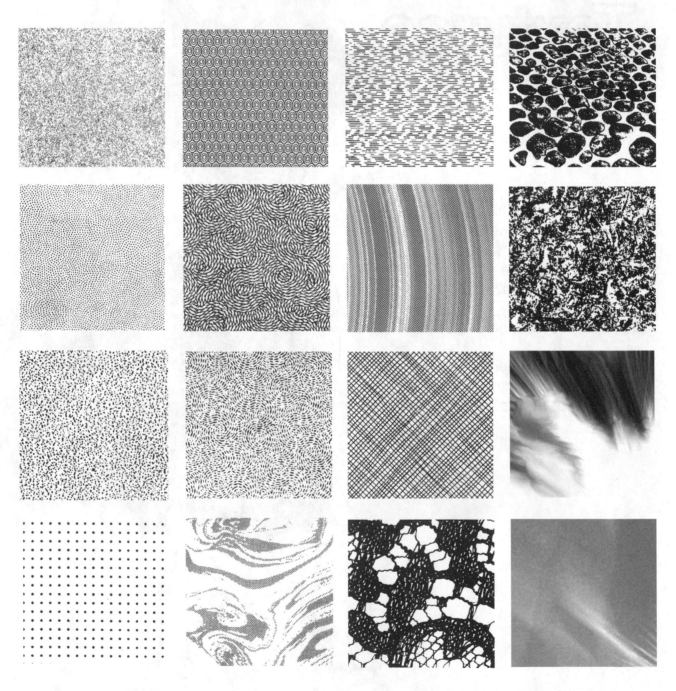

Having premade textures is a great shortcut for adding detail without having to draw elements every time, as well as for adding variety to backgrounds. Textures should be used sparingly, however, as they can quickly clutter or confuse an image.

Handmade Textures

There's no need to feel restrained by pre-made textures, because you can make your own simply by scratching away some of the screentone. These effects can be made in the computer, but this is one of the areas where using old-fashioned screentone sheets is probably better. That's because it's easier to get varied and clean cuts using an X-Acto knife than to make the same effects on computer, though a variety of interesting effects can be made in the computer with customized brushes. I'm using a 100% black tone here so that the marks are easier to see, but this can be done on any value or texture of tone.

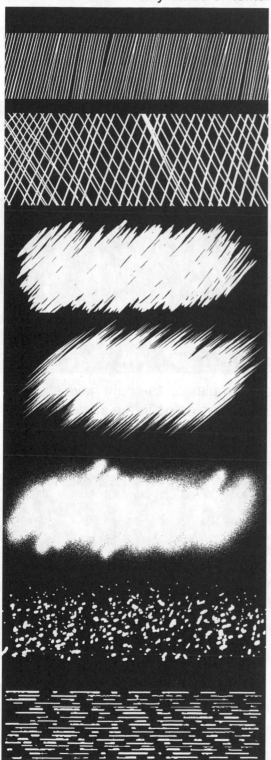

HATCHING—This texture is created by simple sweeps of the knife or brush in one direction over and over. Generally, the more consistently spaced and thinner the strokes, the better it looks.

CROSSHATCHING—The same as hatching, only with strokes in two opposing directions. Shown large here to give a better idea of how it looks. Be warned: Too much crosshatching can completely destroy the image or tone by becoming a hard-to-see mess.

WIDE STROKES—By using the side of the knife instead of the tip, or a more horizontal brush, you can create an effect that looks more powerful than hatching. It covers a lot of area quickly, but looks messier and isn't as intricate.

FLASH STROKES—An advanced form of hatching that involves stroking up and down very quickly over the same areas. Often used to represent emotional states. Inverting the technique so that the inside is dark and the outside is light can create a different kind of mood as well.

ERASER—This tone can be created by rubbing an eraser over the tone or using an airbrush. It gets a softer fade than you can create by using a knife, and is most often used to suggest certain kinds of soft lights or textures, like glowing effects or soft leather.

STIPPLING—Created by simply tapping down your instrument over and over almost at random. Be careful, though. If you're making loud knocks when you bang the knife tip against the table, you're doing it wrong, as that will only damage the instrument. You should try and concentrate on softer, more controlled nicks in the tone.

AND MORE—Skipping lines, spirals, penguin shapes... you can cut any kind of line you want into your tone. There is nothing stopping you. Experiment and have fun! with it!

Creating Hatch Marks Effectively

When creating your own textures through hatching, the idea is to create a sense of gradation, to let the dark colors seep in slowly. To this end, you are going to want to create a consistent, clean line.

Key points to having good-looking hatching are:

-Keep the lines straight
-Keep the lines thin
-Work at an angle that is comfortable for you

This is one area of toning where using adhesive sheet screentones and cutting tools has an advantage over digital toning, because fast, precision marks with an X-Acto are fairly easy to create with practice. Making the same marks on the computer can be very slow, tedious and difficult.

The examples on the left use very sloppy hatching and are totally unpleasing to the eye. The effect of gradation is lost and they just become a mess.

The examples on the right have straight, precise lines going in the same direction, create a better sense of gradation, and so are much more pleasing to the eye.

Remember, having all the lines go in the same direction is not enough! They must also be straight, otherwise the eye will start creating optical illusions. A little bit of wobble like in Figure A or a curve like in Figure B both seem to have properties that are not in the actual etching, because the etching is awkward and the human eye is funny that way. Figure C, however, with its straight lines, is correct.

Figure A

Figure B

Figure C

This is how the etching seen in Figure C will look when it is on actual screentone.

Figure D

The image in Figure E is an advanced example of hatching and crosshatching used effectively. Note how various amounts of light and shadow seem to be created by how many lines overlap in a certain area.

Also notice that not all the lines go in the same direction throughout the image. This helps create a variety of shapes and textures, giving the appearance of multiple surfaces. If you look closely at the groups of lines, however, the lines consistently go in the same direction in their individual clusters.

Hatching and crosshatching is an art all by itself that takes a lot of practice. I recommend practicing with black-on-white line drawings using a pencil or pen, at length, in order to get a grasp of it before trying to apply the principle to tonework. When working on tone, you are basically doing inverse crosshatching, applying light to dark instead of vice-versa.

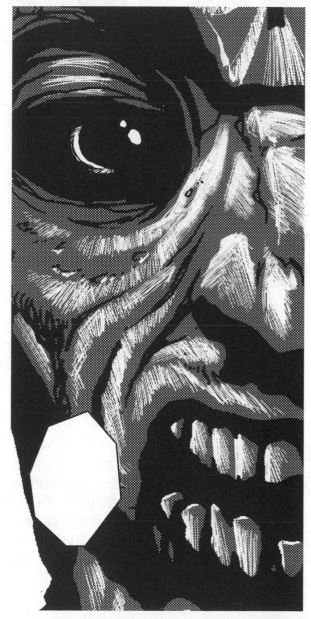

Figure E

Ominous Moodsetting

Sometimes when dealing with villains or night scenes, you'll need to create a darker, more sinister mood. Luckily, if the art does a good job, making a scene more evil and sinister is really easy! So easy, it's almost...evil....

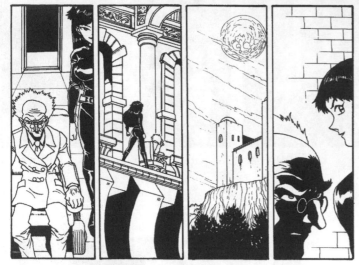

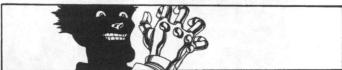

In this sequence, we have an evil, old villain in an evil, mechanized wheelchair, going down an evil hallway in an evil castle plotting evil things. In the last panel, he's even gloating over a bunch of young kids that are probably the innocent good guys!

Clearly, to help show how evil this villain and this place are, we need to find a way to tone the scene to make it more sinister. Luckily, it already has heavy blacks indicating shadows, as well as a moon in the sky, so the art is helping by making this an obvious nighttime scene.

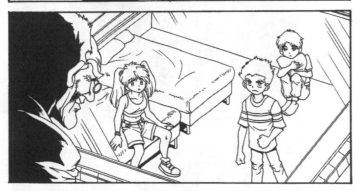

Sometimes, all you need to do to add evil to a scene is drop a solid, mid grey tone on it. Leave tone off any obvious light sources like the moon, and when you combine it with the heavy black shadows, you instantly have a dark and ominous scene!

If you just want to get in and out of the page, you can actually stop there, because the point that the area is dark and evil is made. I don't suggest it, though, because that's pretty boring, and it's obvious you did it quickly without putting in much effort. You can easily take it a step or two further.

Here I've taken a couple of extra steps to enhance the page. I used both a light and a mid tone to add more depth to the scene, and cut away areas of light to define the characters. I've kept the white areas to a minimum to try and enhance the ominous gloom.

Notice the heroes have a well-lit room compared to the dark areas outside. It isn't that the villain is giving them a nicely lit room, but that I'm once again drawing attention to a particular spot.

Sadly, the page lost a lot of the mood it had when it was just one tone. Despite having already done the work of making two sets of tone, I decided to go back. (This is really pretty easy to do in the computer. Had this been tone sheets, I would probably have let it be.)

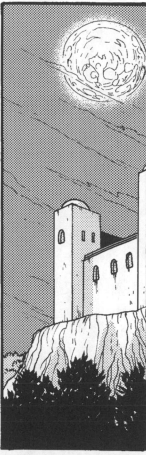

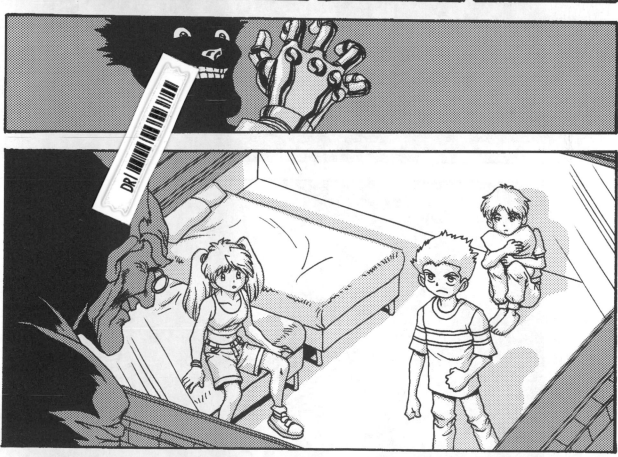

In this case, I think the page looks better with a single dark tone. It just helps the atmosphere by giving everything starker contrast and more sinister lighting. Sometimes simpler is better, and in this case, one tone works better than using two!

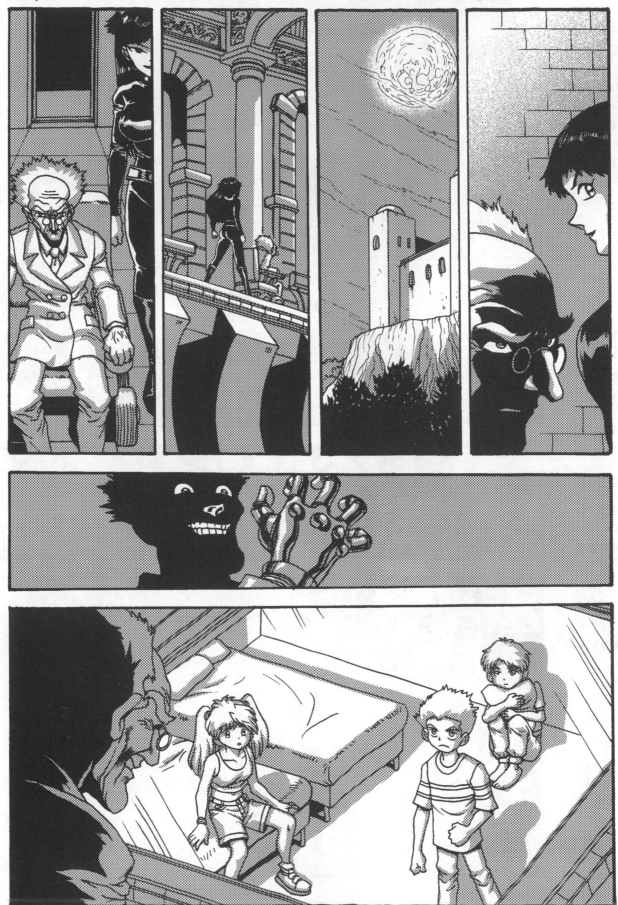

Backgrounds from Scratch

Sometimes, the artist will leave an empty space because he intends for the background to be a complex visual, and too many lines or details can be overwhelming or confuse what the focus of the piece is.

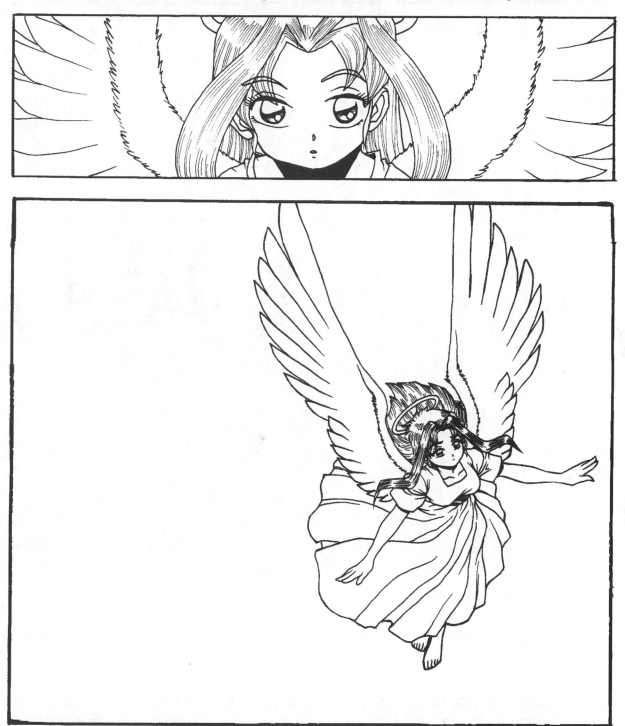

This particular page came with the note to put in an "ancient, Mesopotamian-looking city from above," so I hunted through a variety of reference materials until I found something I was VERY sure would fit the bill. I was about to put in a lot of work to make a city from scratch, so I wanted to be sure I had something that looked good before I started. I actually had the convenience of asking the artist his opinion once I found an image, but if that isn't an option, you just have to trust your judgment.

You can't just start dropping in tones once you have a piece of reference, or everything will be off-kilter, lopsided, and sloppy. You need some kind of guideline. I recommend using a ruler and lightly drawing in the basic shapes with a blue pencil. You don't need all the details, just the basic idea.

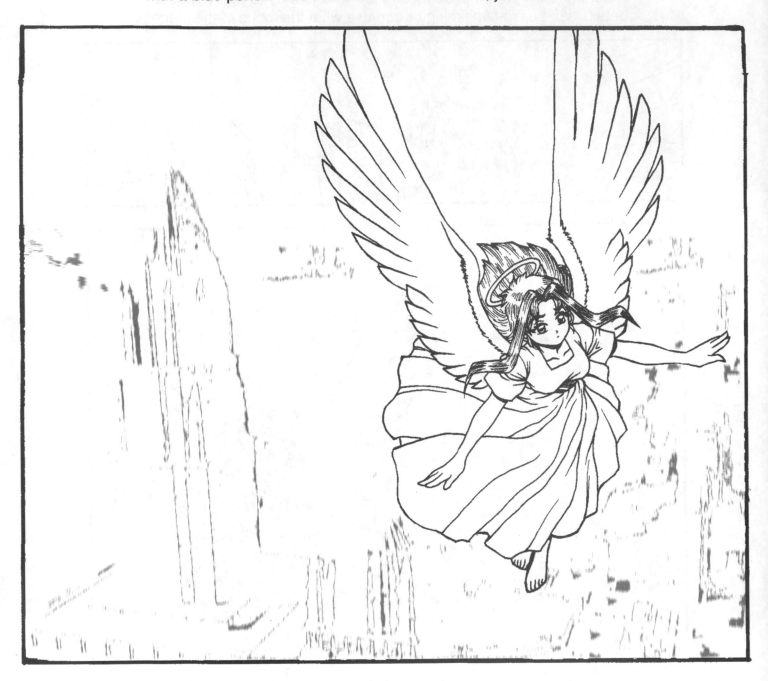

In this particular example, I went through extra steps to make the blueline sketch visible so it could be seen for the lesson, but normally you won't be able to see blueline once it is photocopied or scanned (hence the reason for using blue pencil instead of a normal one). It won't show at all in the final result, but keep in mind I have it there. I am NOT just putting in tones randomly, and neither should you. A guide of any sort is always better than none at all.

Because this image is going to end up being fairly complex, I do the easy part that I'm comfortable with first—namely, the figure. Not only does it get that part out of the way, but it also helps me see how and where the entire piece is going to need lights and darks to balance it out and keep the character as the prominent feature of the page.

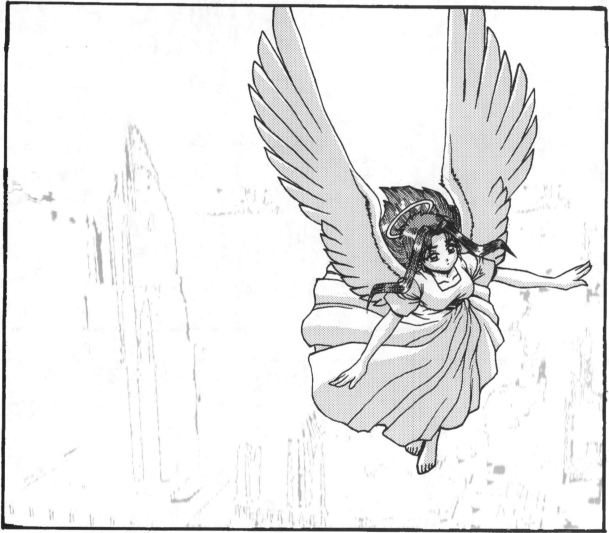

I'm going with generic overhead lighting on the character, because as always, if there isn't an obvious better alternative, overhead lighting will do fine. Also, in this particular case, it puts the character in a near-silhouette, which will help make her stand out when the page is done.

As a side note, notice that the wings cast a shadow on her, because after all, they would be blocking the light directly behind them. This helps round out the illusion of depth and also serves to help put the character more in near-silhouette.

With the character firmly established, I decided to put in the dark tones for the cityscape first. A big advantage to doing the dark spots first is that the shadows serve as solid areas to look at and build from, whereas light areas would go into white and fade, making it a lot trickier to tell where they start and end. Do the shadows right, and the rest should be easy.

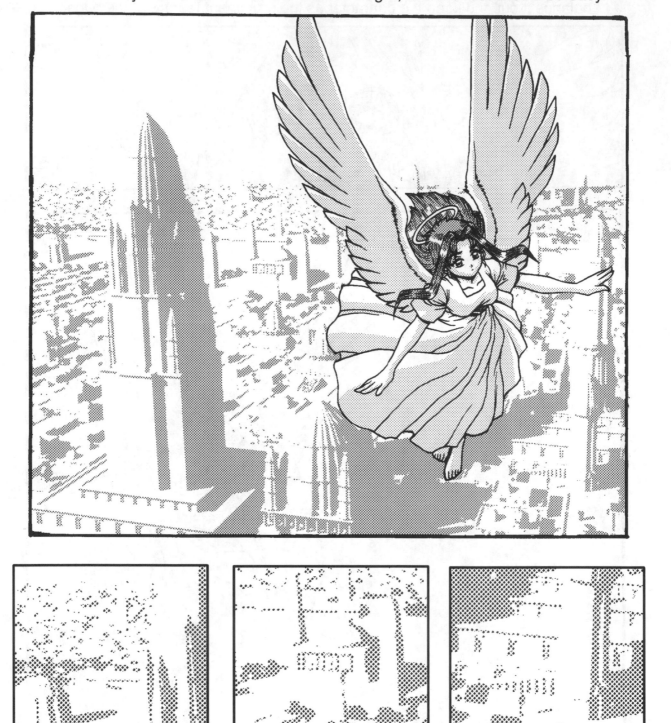

The important thing with doing heavy shadows first is to be sure to get the forms right. Even without line art or a light tone, you can readily make out the shapes and the structures of the buildings.

Also notice I put large amounts of heavily shadowed areas around the character, which helps to push her forward even more. Because I carefully planned the page out early on and chose my reference well, I was able to create a composition that would lend itself to the character nicely.

Finally comes the light tone on everything. This part is really, really tricky, because you have to follow the guidelines you've set with the dark tone and figure out where the extreme light sources are that you will leave entirely white. This takes a lot of consideration and planning, and I cannot stress enough how important it is to have a good reference image when doing this level of background creation.

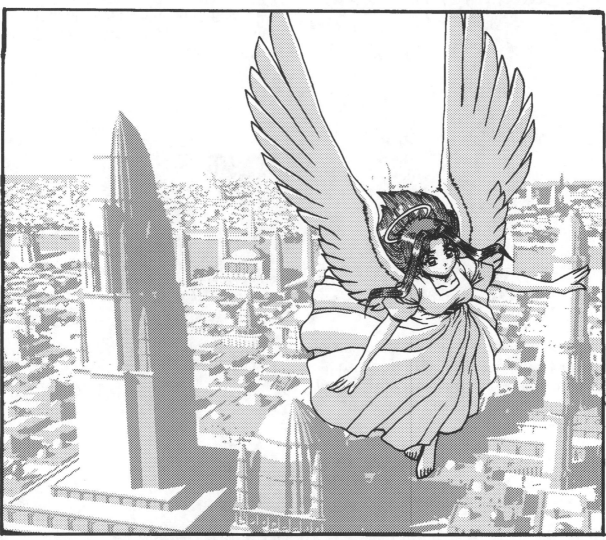

This entire process is very time-consuming, difficult, and easy to mess up. You should not attempt to do something like this until you've practiced the easier techniques or you have a lot of time to play with it. Counting research, planning, sketching, and the actual toning process, this page took me ten consecutive hours to complete. This sort of toning should not be done often unless you have a very special project that requires it, preferably one with an adequately loose deadline.

Enhancing Drop Shadows

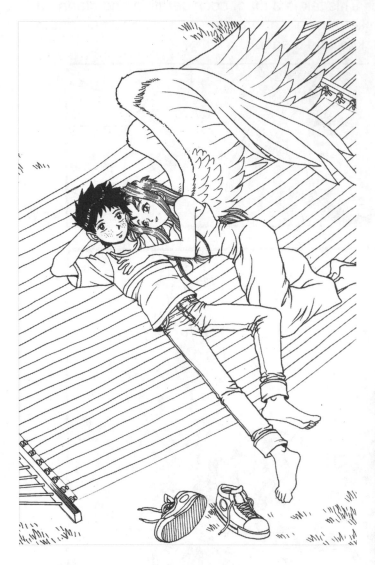

Creative use of shadows can really enhance a scene by showing elements that are not actually on the page. Because everything casts shadows, just showing the shadows can hint at off-scene objects or light sources and add a whole lot of variety to a piece.

This particular image is a pair of characters lying outdoors in a hammock, so they're either lounging around on a sunny day or looking at the stars at night. Since the sky isn't going to be in the shot, getting across a starry night would be very difficult, so I opt for a sunny day.

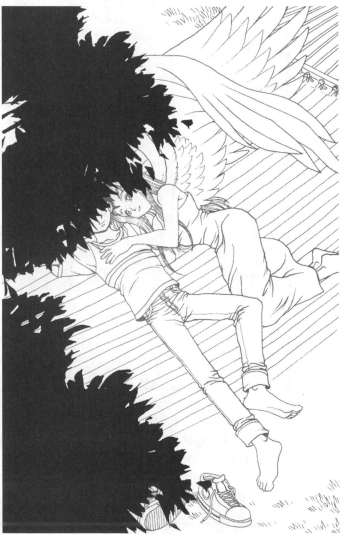

The hammock has to be attached to something, and hammocks are usually tied to trees, so I figure that the tree would be casting a shadow down upon the characters, and I set about making a tone cutout.

In this example, I've made the selection a solid tone so it is easier to see the shapes—in this case, a mess of sporadic leaves.

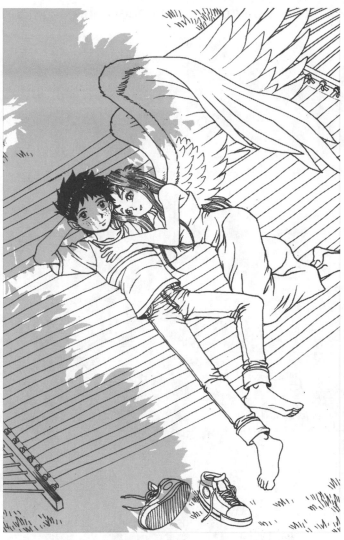

Here's how the shadow of the tree looks when it is not a solid black. I've worked it around the characters so that it helps push the background aside and make them even more the focal point.

I've also made the leaves overlap the characters a little so it will feel more like a natural element, instead of something that was just dropped in.

Finally, I go through the process of adding shadows to the characters. Because the shadow of the tree IS a shadow, I make sure not to have any tones be darker than it. Otherwise, it would look weird.

The finished product all blends together pretty well and makes for a solid image that is much stronger than the art was on its own.

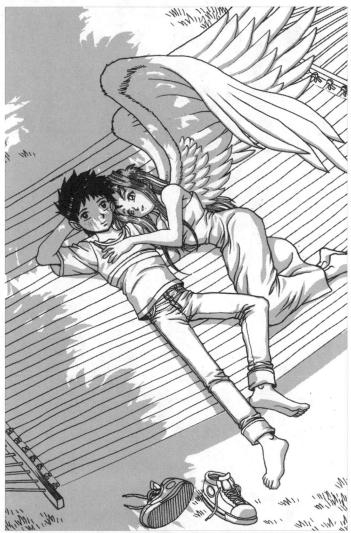

The same basic idea can be applied in other cases where a drop shadow can be used to hint at objects not on the page. What object is blocking the light from off the page in this example?

Empty Backgrounds

Sometimes, the artist will draw no background and leave it up to you to figure out how to make the page interesting.

In this particular instance, there are no backgrounds because the characters are in a sort of null-space, where no solid objects exist, but this sort of thing may pop up frequently, depending on the artist and the story's setting.

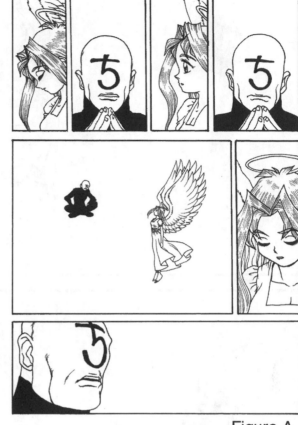

Figure A

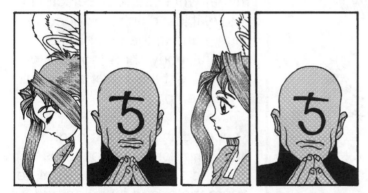

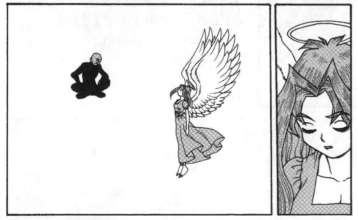

Figure B

In a scene that is this bright and empty, it is crucial that you figure out where the areas of tone are going to be to help separate the characters from the empty background. In Figure B, I placed down tone where I thought it would be used heavily.

Due to the extreme light the area suggested, shadows were probably going to be very minimal. Because of this, I wasn't entirely sure how much tone was going to be on the lighter areas, like the face and wings, so I held off on putting it there until I had a better idea of how much would be needed.

I cut away areas on the tone where light would be hitting, and now that I had an idea of how the shadows looked, I applied tone to the wings and skin. However, the scene was still really empty-looking.

Figure C

In Figure D, I briefly tried giving the characters shadows, but no matter what shape or selection I made, it just didn't look good. Plus, none of the other panels were full body shots, so they wouldn't get this effect and would remain empty.

I once again hunted through my archive of tones and patterns to try and find something that might be appropriate, and found an odd, swirling pattern that I thought might be interesting.

Figure D

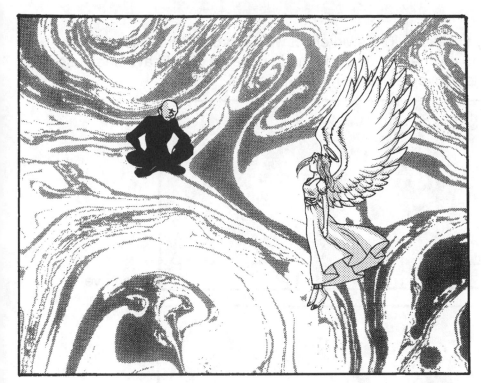

The swirls did their job well and created a very interesting effect that I liked. So I placed the swirl screentone pattern down in the background for all the panels, and was surprised to find that it was completely overwhelming the page.

Figure E shows the panel at full size and why it looked good on its own, but Figure F shows how overwhelming it was on the page as a whole.

Figure E

I liked the effect, but it was just too much. So I found a lighter, less overwhelming screentone pattern that created the same effect and applied it a little more sparingly so that the characters would remain the focal point. Figure G is the final result.

Figure F

Figure G

The same rules can apply in almost any situation. The swirl effect was appropriate to this particular scene, but had the context been different, a variety of other premade patterns could have been used. Sometimes they can even be used just to convey emotion in a single panel.

In a cave

In a forest

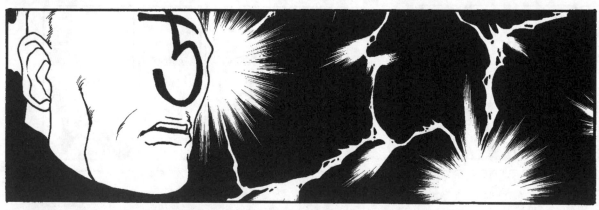

Shocked

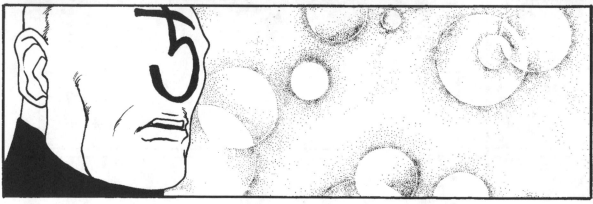

Mystical, Cosmic or Underwater

These are all cases where a pre-made screen pattern was used to create an environment the artist did not draw. If you are toning a story where the characters are regularly going to be in the same place, having pre-made backgrounds can be a big help for the sake of consistency and saving time.

At its most extreme, a default screentone placed into blank background can add a great amount of physical and emotional depth to a panel by providing a very moody, textured image The close, rugged nature of the lines in the background really forces the readers to concentrate on the character, without having just a blank page to lead their eyes.

Using Flat Textures

Sometimes when toning, you'll come across art that just doesn't lend itself to toned shading. This happens when the art is full of details or makes use of heavy black, and screentone shading just seems to get in the way rather than enhance the piece. In cases like this, flat textures can work for a piece better than rendering shadows.

Figure A

As you can see in Figure B, regular shading just doesn't seem to help this piece that much. There's so much detail and rendering in the characters and backgrounds that adding a shadow does not really help pop out any elements.

Figure B

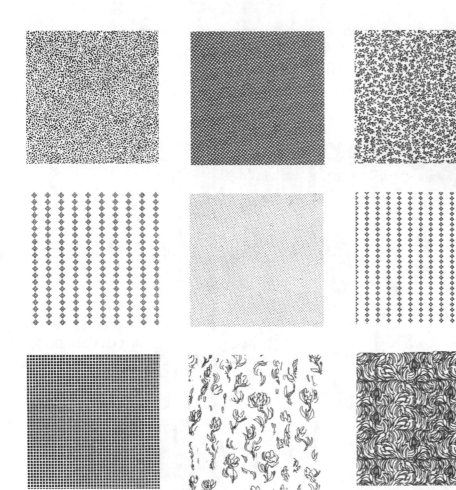

So I tried to use more texture than shading for this image. I hunted through my archive of tones and textures, looking for various patterns that simulated texture and that were also appropriate to the setting, which is elegant and classical.

I found several patterns that I thought would work, and I started studying the piece to try and figure out what might go well where.

If you're working digitally, you can play around with many options. Screentone sheets require more advance thought, as they cannot be changed easily.

You can also work on photocopies if you are completely unsure of what you are going to do.

In figure C, I started placing tone patterns, then quickly discovered I did not like the results. Character balance was being lost because there were too many dark tones, and I didn't like the textures on any of them. Also, the background had become confusing due to too many vertical lines.

Figure C

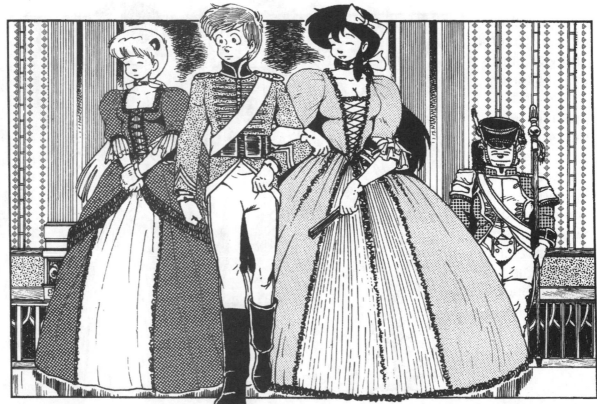

Since the first attempt produced so many results I did not like, I decided to try some different tones, lighter and more subtle this time, and also not to place tones on so much stuff as to make it cluttered. I started by considering the background, and ultimately ended up using a little leaf pattern, which works well by breaking up all the vertical lines and giving a sense of elegance.

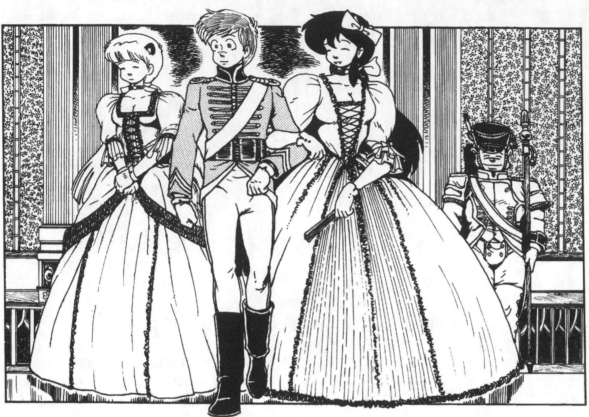

In figure D, I used a lighter, less textured tone than before on the male lead, and it looked a lot better. The piece looks good at this point, as there's plenty of texture filling it out now, but it still needs a little bit more to balance it out.

Figure D

Extra textures on the soldier and wall finish the backdrop. A light and open flower pattern on the girl's dress adds to the elegance without being overly cluttered and distracting. Figure E is the final product, and it looks pretty good.

Figure E

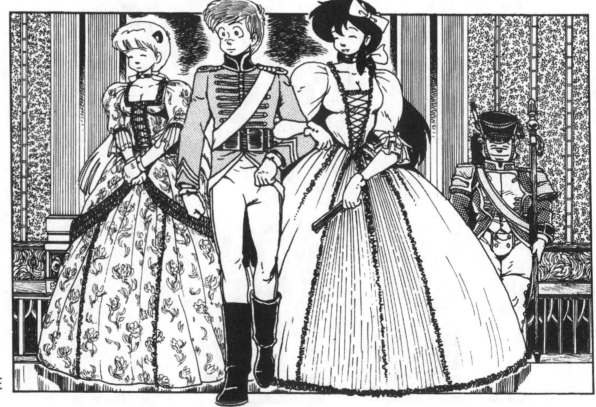

Flat textures can be used at almost any time in any setting, as long as your are subtle about using them and it is appropriate. When you want something to have a unique and consistent rough texture, but drawing it in would be difficult and time-consuming, that is the time to apply flat tones.

Here texture is used to give the appearance of rough fabric to the characters' pants and couch, which enhances the look of the whole panel. Also, by using it specifically on those spots and not the shirt or hair, it helps push the character forward by making his face and torso the cleanest and easiest things to see in the panel.

The exact same idea is applied in this panel. By adding a great deal of texture to the background, it gives the background a lot of depth and shadow, which serves not only to make the setting more realistic, but also to push the character forward.

Notice that in both cases, the screentone texture is not the only texture used. The actual drawing already incorporates hand-drawn patterns, like the carpet, wood grain, and throw rug. Having hand-drawn textures combined with default screentones adds variety and makes the piece look more natural.

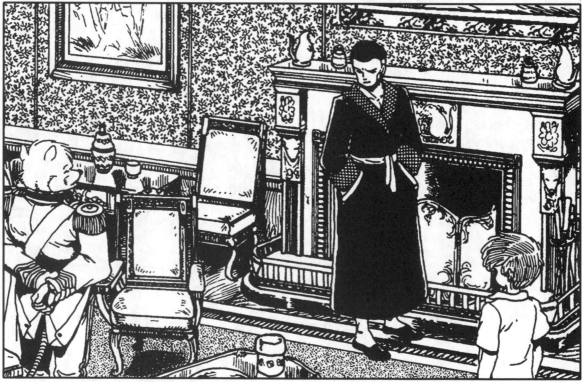

In a shot this elaborate, with ornate furniture and a number of little decorations, it looks awkwardly empty if it is not filled to the brim with detail. Once again, using the small leaf pattern for the wall, a tiny grain for the rug, and a crosshatch pattern on the robe, we choose textures that all lend a feeling of ornate luxury and detail that makes the image look complete.

Using flat texture is great for building exteriors. If a building is made of brick or stone, there are textures that can be used to fill in the walls quickly. Flat textures come in real handy for building roofs too, where you want to give the impression of a flat surface that at the same time is still full of detail. Check the examples below and see how flat texture quickly and easily completes the images by filling in the roofs convincingly.

Here are some more examples of how a flat texture can be used to complete a drawing. Again, notice that using the tone is not a shortcut for putting in detail. There are many other details in the images to balance the pieces so the screentone does not look odd or out of place.

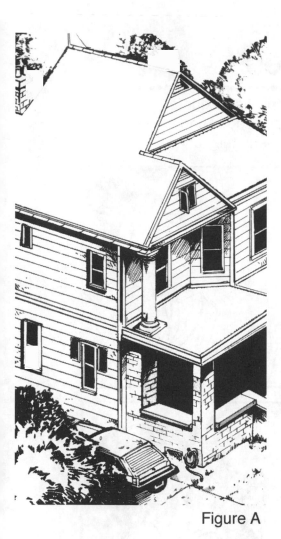

Figure A

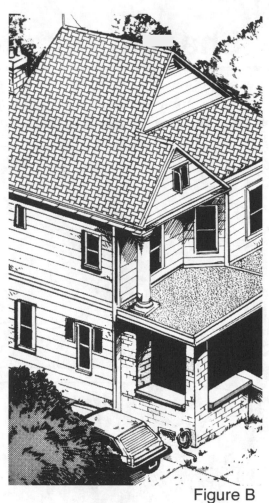

Figure B

You don't have to stop at just applying texture to the roof of a building. Creative application and use of tones can lead to a fully detailed image even when the initial drawing is somewhat empty.

Figure A is the image as drawn. There are drawn details in the boards, bricks, grass and trees, so the image is already fairly strong on its own.

Figure B adds a unique tile pattern to the roof to give the impression of multiple shingles. It also uses additional textures to create a concrete-like appearance on the exposed part of the second floor and to bring the tree in the foreground closer. You could stop applying tones at this point, and the image would look just fine.

Figure C, however, goes the full distance and adds shadows to one side of the building. Because buildings are usually basically square in in shape, one side can be put into fairly heavy shadow and it will look really good most of the time.

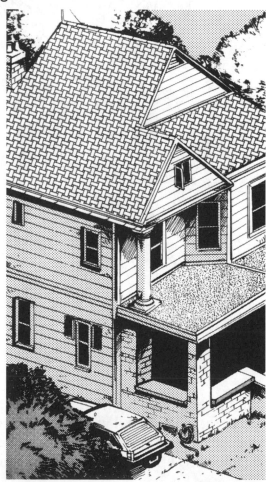

Figure C

Shaping Textures

You've now seen how to render and how to apply flat textures,
and you are probably wondering if the two techniques can
be combined. With a little creativity and judgment, they can.

In this example, we have a woman who is transforming from dragon form. Because her default state is being a dragon, I wanted to do something unusual to make her interesting and stand out amongst the other characters, so I figured adding some textures to her outfit would probably be the way to go. However, I had been rendering everything else in the book, so just using flat texture wouldn't work.

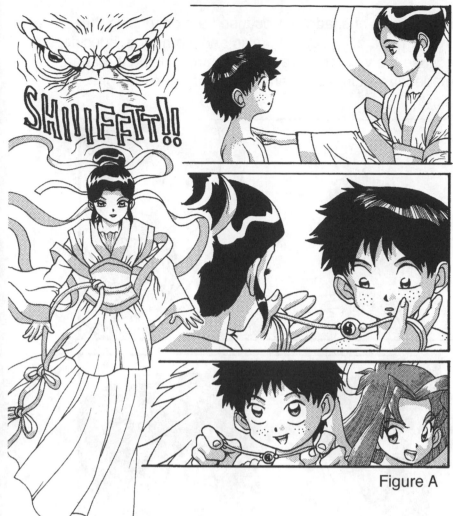

Figure A

Before applying unusual textures, you should do the ordinary, straightforward parts first. The normal stuff is what you do most often, so you will probably be more comfortable doing that. Also, it will provide shading guidelines on the non-textured shapes for you to follow when doing the unusual stuff.

In figure B, I have already applied the light tones to the character and have figured out where I am going to drop the textured tone. For this example, I have used a dark grey flat tone to indicate where the texture will be. Normally however, you would just go straight to using the unusual texture.

Notice that the selected areas uphold all the usual shading practices that would be applied everywhere else. Light is hitting in the same amounts, and shadows are in the same areas. Just because it is going to be a texture doesn't mean it can ignore the rules of lighting.

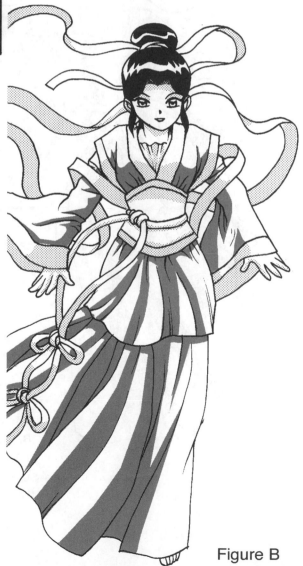

Figure B

Here the texture has been applied in areas of shadow. Because I am only using the texture in shadowed areas and I already have a light grey for skin and cloth tone, I decide to use a very dark texture. Also, because the woman is transforming from being a dragon, I opt to use a scaly sort of texture because it is a little reminiscent of her other form.

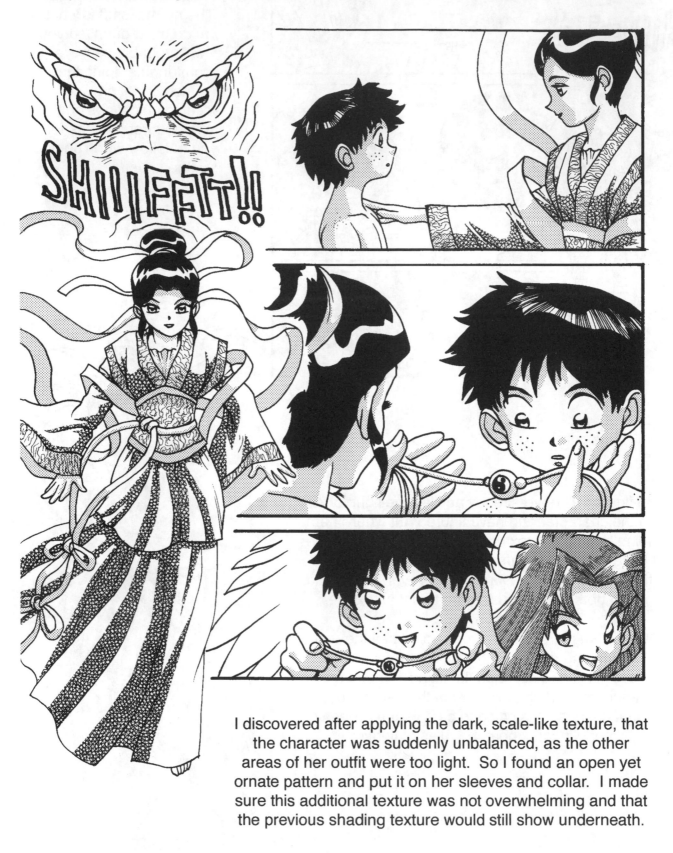

I discovered after applying the dark, scale-like texture, that the character was suddenly unbalanced, as the other areas of her outfit were too light. So I found an open yet ornate pattern and put it on her sleeves and collar. I made sure this additional texture was not overwhelming and that the previous shading texture would still show underneath.

Figure A

Extra textures can be used in all sorts of situations: rocks, trees, cloth, and many other things. Textures can even be used to create interesting looking dog fur.

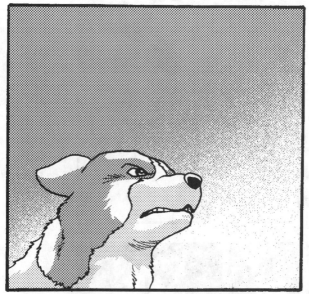

Figure B

Figure B is a case where I was sticking to the two tone rule, but for some reason, the dog was not working. I tried using the two tones in a wide variety of combinations and amounts of lighting, but it just was not looking quite right. Fur is difficult to portray in tone, and even tougher when the animal wearing the fur is multi-colored.

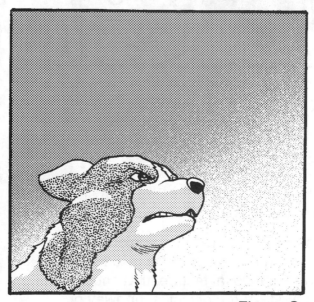

Figure C

In figure C, I tried applying a fairly heavy grain pattern, and it worked wonderfully. Suddenly the dog had a fur-like texture, his different "colors" stood apart, and it helped make him stand out from everything else.

Sometimes you can apply just the texture like in figure D, and it looks just fine. The amount of effort depends on the situation and style you are striving for.

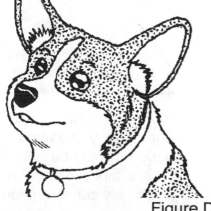

Figure D

Here is a finished page. Notice how the texture on the dog constantly helps
set him apart from the environment and the other characters and toning. This
works so well because it is done sparingly, and only for the dog.

In any situation where you are going to be applying a texture to a recurring object or
character, you should try to use the same texture every time. Changing the texture
suddenly may be jarring or confusing. If you are using an unusual texture, that should
be a distinctive element to the character. However, if the textured object is far away or
extremely close up, you may want to consider an alternative for the situation.

This page incorporates many of the techniques we've gone over so far, while managing to look simple and uncluttered. It has a variety of different lighting angles on the characters. The background was made from scratch and makes efficient use of hatching to give it texture. The background is also darker than the characters to help push them forward. The woman in the bottom left panel has an alternative texture in her shading to help set her apart from everything else. All of that on a simple, random page of talking.

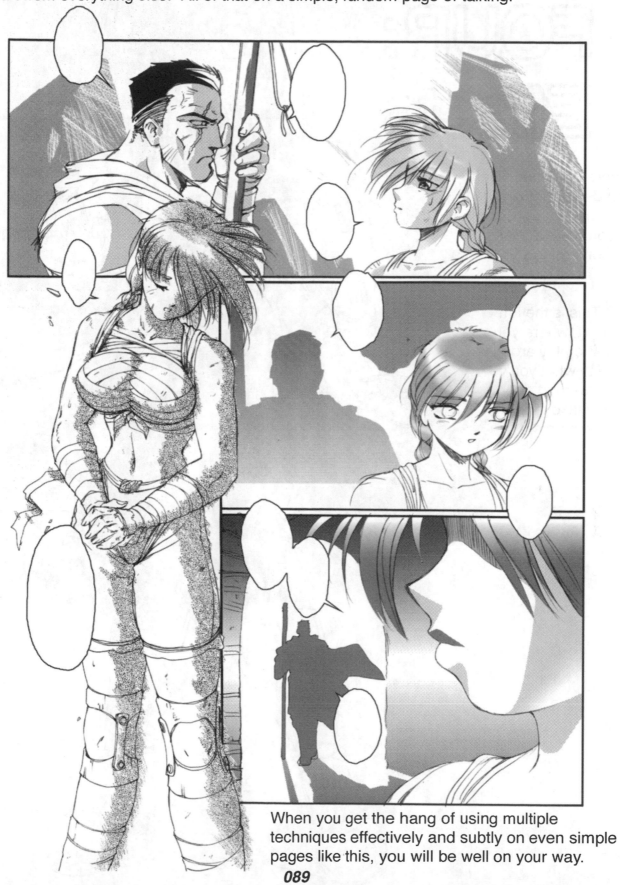

When you get the hang of using multiple techniques effectively and subtly on even simple pages like this, you will be well on your way.

CHAPTER FOUR: Effects

There are times when rendering or textures are not enough, and you have to make something shine and glow.

This is the fun part, where you get to play around with what you've learned and take it up a notch!

Sketchy Etching

A fairly simply effect you can make is to etch areas of light roughly into an image. There are many situations where this effect is appropriate, but it is usually used for very emotional moments or faded memories.

There are several reasons for using this technique, including emphasizing the line art, making an image stand out from others, and also just having the art look visually interesting.

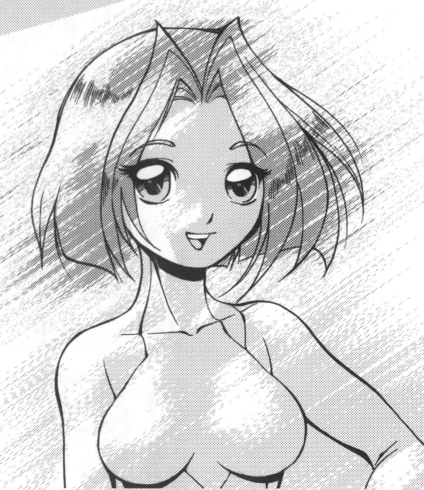

There is no really difficult trick behind this unique visual. Start by placing a large amount of excess tone around the character, including any darker tones you wish to use.

Then, hatch away the light areas using strokes in a consistent direction, until a satisfactory amount of the character and background are lit up, and you're done!

For specific areas of smooth detail, like the eyes or teeth, you may want to render normally instead of hatching.

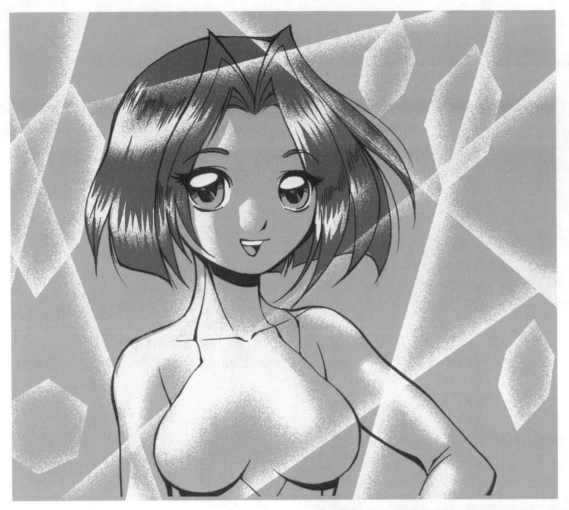

Another effect you can use is beams of light and lens flares. This effect can be used anytime you want to show a bright area or a multitude of lights, or just to randomly mix up the background. It's also pretty easy to do!

Start by sketching out rough shapes or lines the way you want them. They can overlap—in fact, overlapping will create an interesting effect most of the time.

Simply etch away at the insides of the shapes bit by bit, only going a little ways into the shape so a large area of tone is left in the middle.

Erase your guidelines, and you're done! It really is just that simple.

Even in an example as complicated as this, it's still the same idea. Just make one shape at a time, etch it out, then move on to the next. Patience will be rewarded with these kinds of effects.

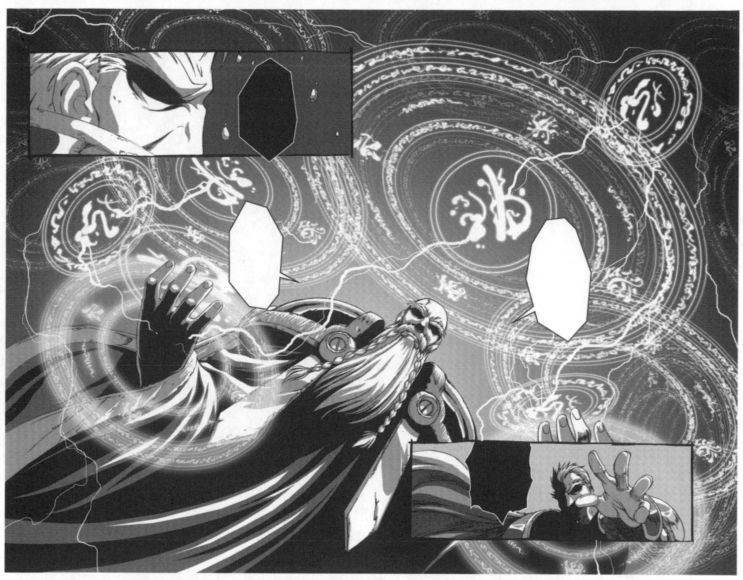

If you look at the image carefully, there's really just a whole bunch of circles in it, with little squiggles between the circular lines. It is basically all nonsensical, but because there is a lot of it, each circle is well thought out and angled, and the gradation etching is done very well, the piece looks complicated.

The time and effort put into it is obvious, and it looks good.

Basic Clouds

One of the most frequently used applications for pure tonework is creating clouds. Luckily, this can also be one of the easiest to perform. Even if the clouds themselves get more intricate, the process for creating them with tone remains uncomplicated.

Basic clouds are simple to create. Plan on using at least two different tones to convey clouds most of the time. First, just put in the dark tone wherever you are going to want sky.

From the dark background, cut away a patch of solid white in a fluffy shape. Clouds have no definite shape and come in an amazing amount of varieties, so this can look pretty much however you want.

If you are new to cloud rendering, you may want to look at actual clouds to get some idea first.

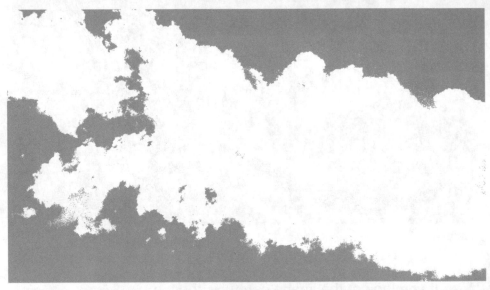

Once you have the white shape cut out, go in and apply a lighter secondary tone underneath the cloud, and try to keep the soft, cottony look.

And it's just that easy to make a basic cloud!

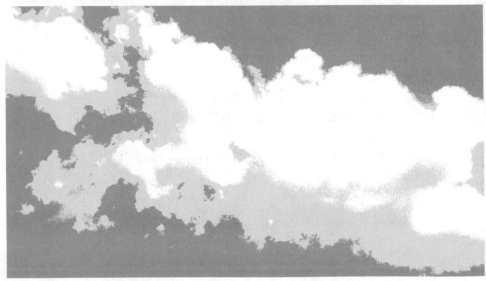

Dramatic Clouds

Dramatic clouds are a good deal more difficult than basic clouds and use a high number of tones, but can be a lot more rewarding if you want the sky itself to be a major element in your storytelling. Usually, dramatic clouds are saved for storms or for extremely intense moments of drama.

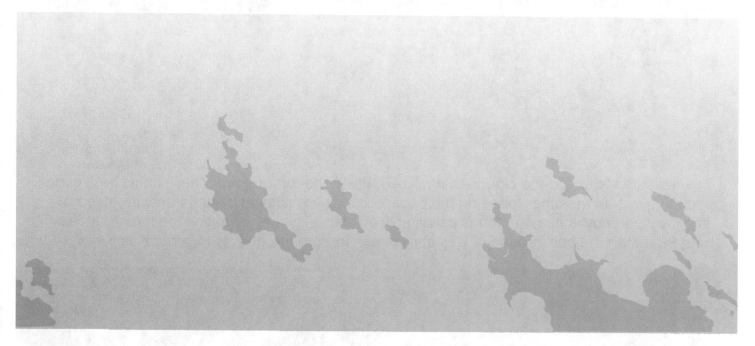

Start off with a light gradation of tone from light to mid grey. (This can be found in screentone sheets or made in the computer fairly easily.) Then, try to figure out where the darkest shadow areas of the clouds are going to be, and apply a mid grey to those areas.

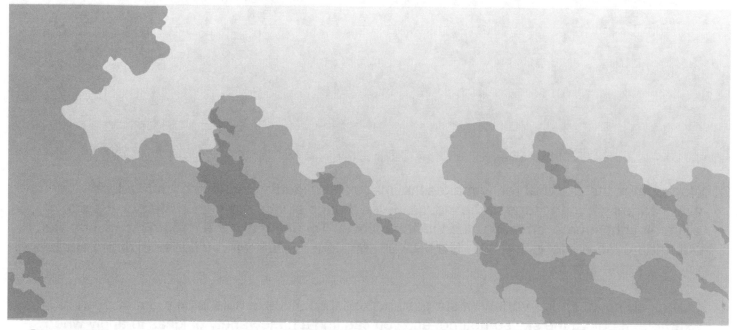

Once you have your basic shadows in place, proceed to fill in the rest of the basic cloud shape with a lighter tone. This light tone will simply go over the dark tone, and they should overlap. If you are using screentone, the dot pattern naturally provides a transparency effect. If you are using a computer, make sure the dark areas are still visible and show through.

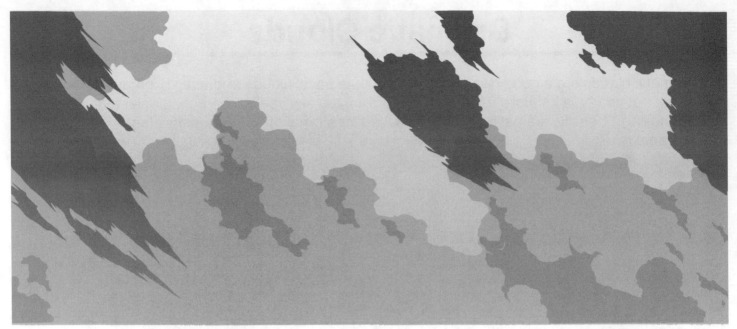

The next step is to add the clouds that will be more in the foreground. They should be a good deal darker than the other tones on the page. Clouds are fluffy and semi-transparent, so a little transparency is fine; the tones can simply overlap. The key is getting the foreground to be darker than the background. (This applies with foreground objects in general as well.)

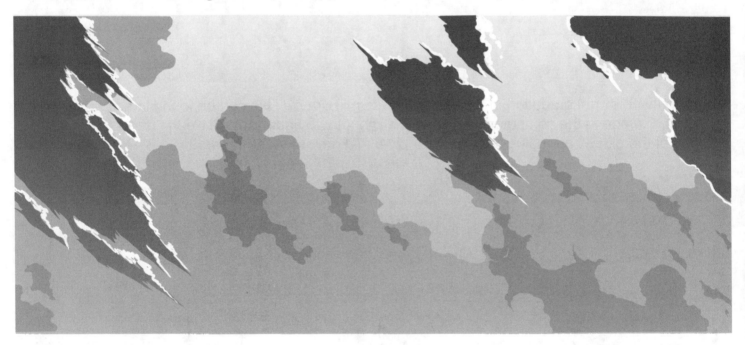

Now comes the part that really makes the image shine: adding highlights. Just add a little white edge light to the tops of the clouds. Even though clouds are high in the sky, the sun is still their light source, so they will be lit from above. Try and make the foreground clouds stand out and be more interesting than the background clouds. This will provide both depth and interest to the image.

Clouds come in a huge variety of shapes and sizes, so this example is only just that, an example. Look at the sky sometime, and you can find a huge variety of ideas to apply when making clouds, and your imagination can provide even more. Just play with it and practice for a while.

Another thing you can try to do with dramatic clouds is have the foreground clouds form a frame, pushing your attention toward the middle of the panel by using the dark shapes and white highlights. The example below follows the steps of the previous pages, only it is more geared toward pushing the eye to toward the middle. In this case, the storm itself is the focal point, and drawing the eye towards the center helps emphasize how massive and cloud-heavy the storm is.

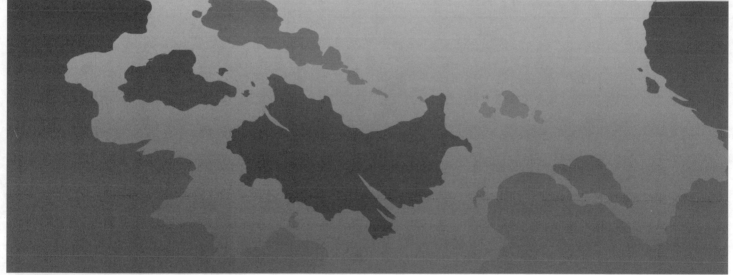

Rain Effects

Creating rain effects is simple. Once you've done all your toning and have effects
you are happy with, you can add the final step. Get out a straight-edge ruler and
your white ink (a white-ink pen is best for this), and create straight, thin lines through
the art and tone. If you've practiced at hatching lines, this should not be any real
trouble. This applies to working in the computer, too—just work right through the art.

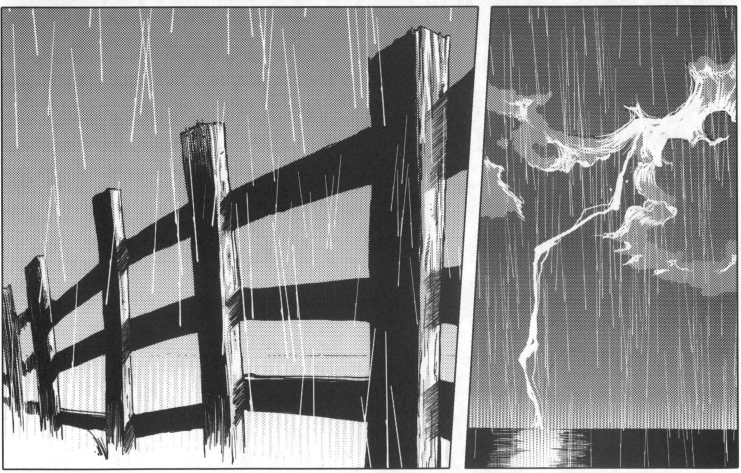

The big secret to rendering rain is IT DOES NOT ALL GO THE SAME DIRECTION. The shape
of the cloud, wind and gravity all distort the drop trajectories so that they fall almost randomly.
If you have all the rain going in the exact same direction at the same angle, it will just look like
speed lines. As long as it is all going towards the same destination, it should look fine.

Unusual Lighting

Magical, glowy objects, fire, rooms filled with turned-on televisions, or any number of other things will call for unusual lighting choices and effects and should be considered carefully. Later, I will discuss lightning and fire effects specifically, but for right now, let us concentrate on just the actual lighting aspect of oddly lit areas.

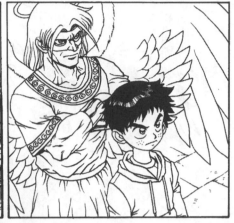

Figure A shows the line art, and there is no indication that any sort of unusual lighting is occurring. However, the script says the sword is magical and impossible for a normal person to touch.

I take "magical" to mean "special and worth showing off," and so decide I'll have a beam of light surrounding the sword and have that be the only light source in the room.

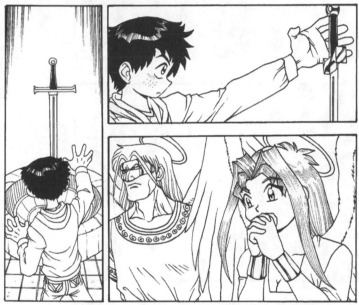

Figure A

In figure B, I drop down all the mid grey tones.

I don't bother working around the hero's hand in the fourth panel, because it is going to be bathed in light, and it isn't really worth the effort to work around when the tone in the area is soon going to be obscured anyway. Sometimes you can save a bit of trouble if you have specific ideas planned in advance.

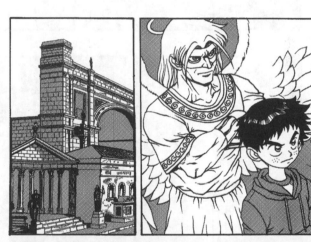
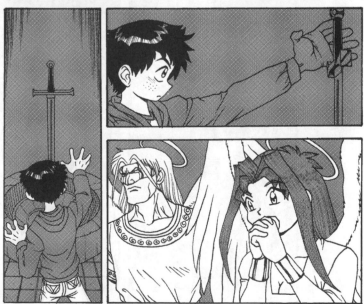

Figure B

Here I do the initial effect of the sword bathed in light by carefully etching the tone away to create a glow effect. I do this first so I can get a better idea of how bright the light is and just how lit up the characters should be. Note the subtle light on the floor in the second panel.

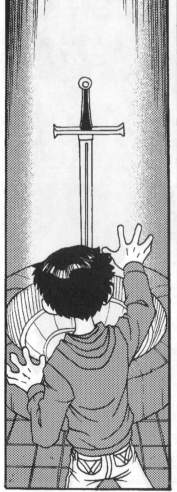

I now know how intense the magical sword's light is, so I feel comfortable lighting the characters, keeping all the usual details like cloth folds in mind. I usually use a light grey tone for highlights on the hero's sweater, but this is unusual lighting, so I go with stark white.

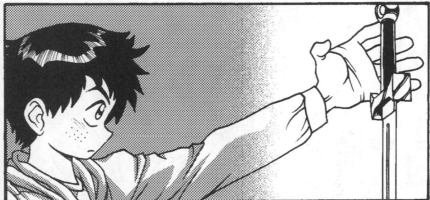

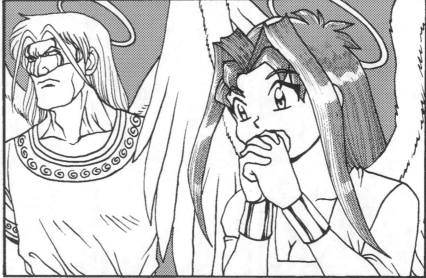

Finally, I place in the light grey tones where appropriate, taking into account the same lighting I've already implemented on the dark areas. If I'd wanted the sword's light to be REALLY intense, or the scene to be more ominous, I probably would have used just the mid grey tone for all the shading.

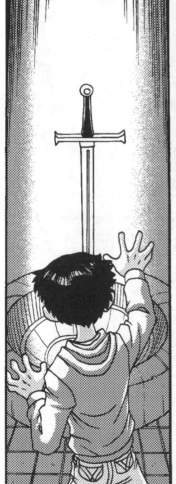

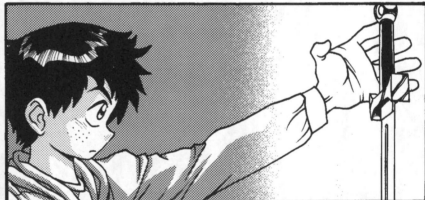

Celestial Bodies

Night skies are an element that almost any story will eventually have. Be it a romantic date at a cafe, a stroll through town, an outer space adventure, or...a dog-man holding a ring for some reason...you will eventually have to create a starry sky. Luckily, there's many easy ways to do it!

Here is the image with a simple blank background. Passable for a single panel, but in a star-filled sequence, it would not do at all.

Notice all the following examples leave a white outline around the character to help separate him from the background.

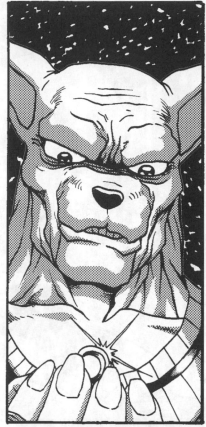

Here, straight black was added, and then stars were stippled in. This method is okay and gets the point across, but it is fairly time-consuming and stressful on the hand after a while. Also, it is easy to slip when you are making marks and create nasty blemishes in the piece.

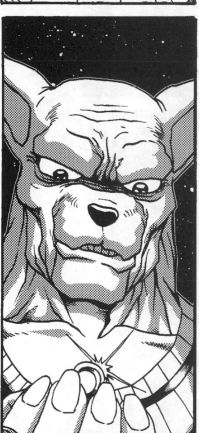

Again, straight black was applied. Then, a little white ink was placed on a toothbrush and splattered lightly across the piece (after covering the areas on which we you don't want white). This is probably the best method because it is quick and creates a truly random star pattern.

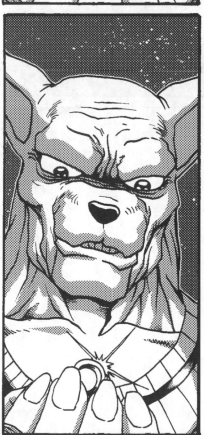

In this instance, a dark grey tone of 50% was applied, followed by the white-ink-on-toothbrush technique. This is good for helping to keep the background separate from the character. However, depending on the opacity and spacing of the screentone, the effect of the stars may be difficult to see.

If the only thing about space that ever needed rendering was stars, things would be simpler. However, there are occasions in which you will be called upon to do continents, moons, or even entire planets. This is a fairly tricky process, but if you go step by step, it isn't too bad. In Figure A, I've done the background on a dark grey, along with the stars and some speedlines.

Figure A

Figure B

The first and probably most important step is laying down a mid grey foundation tone to serve as the water and darker, mountainous areas of the land.

When laying down the tone, try and keep a basic continental shape in mind. You don't have to get it exactly right by any means. The steps that follow will change the look of everything completely, so the basic shape is plenty.

Also, figure B is a simplified example of the type of shape you will create. You will not lay the tone down like that.

Figure C is the shape you will actually be creating in the tone. By putting down a solid layer of mid grey, then cutting away, this is not difficult at all.

Don't be overwhelmed by the deceptively difficult look of the marks here. Keep in mind the basic shape as seen in figure B, and then leave random gaps in there. There is no need to be textbook-accurate here. Again, most of these details are going to be changing as you progress anyway.

Figure C

The next step is pretty straightforward: Apply a light grey tone over the remaining landmass. The reason for this is that the clouds and atmosphere are going to be white.

Also if you are toning any characters in the shot, they should probably be about done at this point.

Figure D

This is the fun part, the atmospheric clouds. This is a simple matter of cutting away white in swirly patterns in pretty much any manner you like. Because clouds always shift, there is no single way to do this. Cut through both layers of tone already there and have fun with it. Also, Antarctica is large and covered in snow, so if you show the bottom of the planet, you may want to put extra white there.

Figure E

At this point, you can go in and add another layer of tone to create darker areas (here the ocean is darker) and to suggest the curve of the planet. Some extra dark areas can add depth to the sphere and give a wider variety of contrast to the image.

Figure F

Finally, with all the tones in place, you can go back in and etch away more white areas, redefining clouds and adding an edge light to round it out to look even more spherical. Try using this same basic method for establishing shots closer to ground. Experiment and see what you come up with!

Figure G

Different Effects

A lot of times, you'll have a page that requires multiple effects, where using just one technique won't cut it. In instances like this, you'll have to think carefully to pick and choose what you want to do and how much time you want to spend on it. Usually, you find the most interesting element of the page and try to make it look even more interesting.

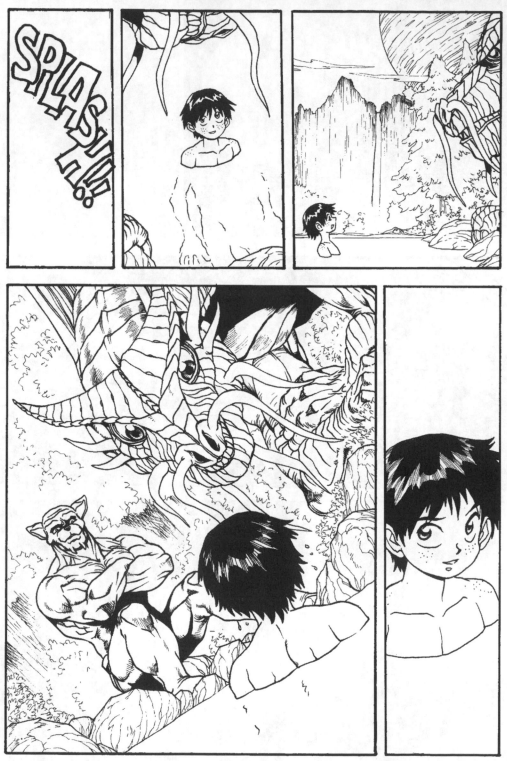

The things that are of most interest in this page are the dragon and the fact that the kid is in the water. This will allow opportunities to create both rock texture and water effects, both of which can easily be made visually interesting.

I start by dropping in all my basic tones throughout the page. I'm going to want the focus to be on the characters and water, so I leave the far background stark white. For the figure under the water and the stuff in the extreme foreground, I use a darker tone to make those elements stand out.

The first thing I render is what I think is going to be one of the most fun elements: the dragon. Something with a lot of scales like the dragon has may seem like an intimidating thing to light, but it's really pretty easy and rewarding if you just take it a step at a time.

I begin by rendering the brow ridge, because that is closest to the foreground and the light, so it will be the largest selection of light and will set the standard for rendering everything else.

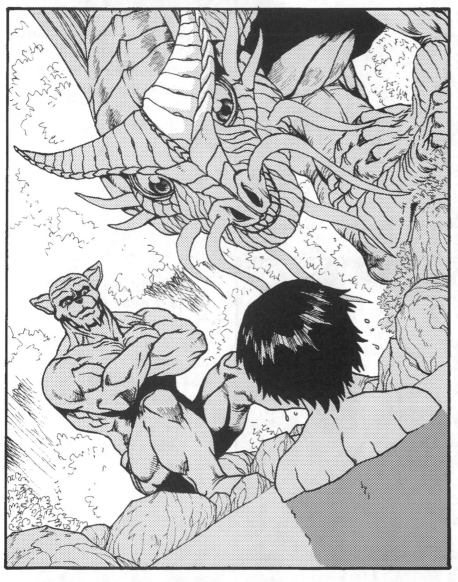

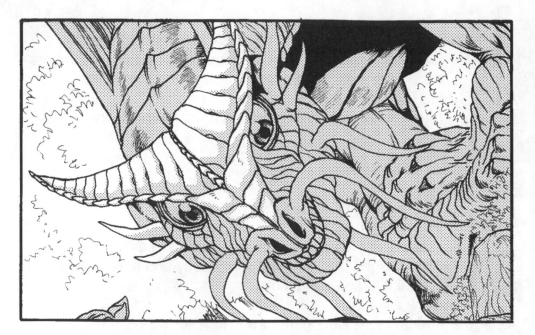

I finish off the brow ridge, making sure each scale has an appropriate amount of shadow. With this element done, already one of the most important parts is finished.

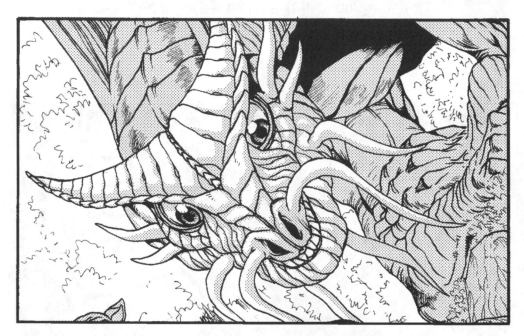

Next, I do the rest of the face, again going one scale at a time. The highlights are, for the most part, smaller here, because the scales are smaller and they further away from the light than the brow.

From there, it's an easy matter to light the rest of the dragon, neck and arms alike. Again, keep in mind the light source and place heavier shadows where they would fall naturally.

With the complicated dragon completed, I then move on and do the lighting for everything else, other characters and background elements, without much trouble.

Because dragon scales are a unique texture, this is a fairly opportune time to use a special texture as demonstrated earlier in the "Shaping Textures" section. This unique element instantly makes the dragon more distinct and interesting.

I also use the same texture on the rocks for the sake of showing the dragon's scales have the same sort of look and feel, as well as to balance out the composition.

On the computer, this sort of adjustment can be done easily. If I had been using sheets of screentone, I would have shaded with that texture the whole time.

Here's how the page looks at this point, with the character and background rendering finished, but not the water effects. I stop and consider how exactly I want to do the water effects, because there are multiple ways to create them.

One method to showcase water effects is to etch thin lines into the water to represent ripples and churning water. This method works well, but in this case does not add enough variety for my taste. I am, however, pretty pleased with look of the first panel and will leave it alone.

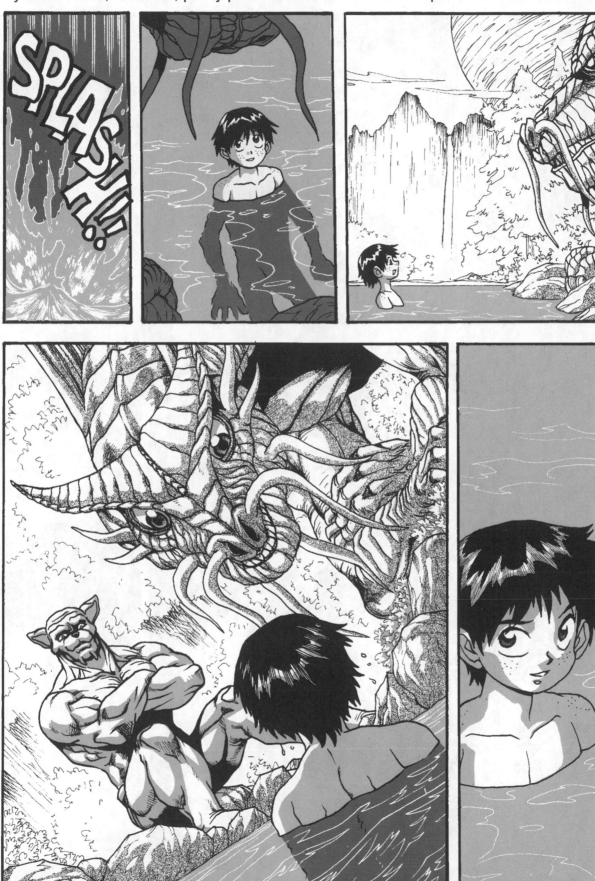

The other method for rendering water is to put large white highlights where the light hits the curving waves and ripples, and that is the method I prefer here because it's a very clear visual. Water can be tricky to do, and like many other things, it helps to look at photo reference.

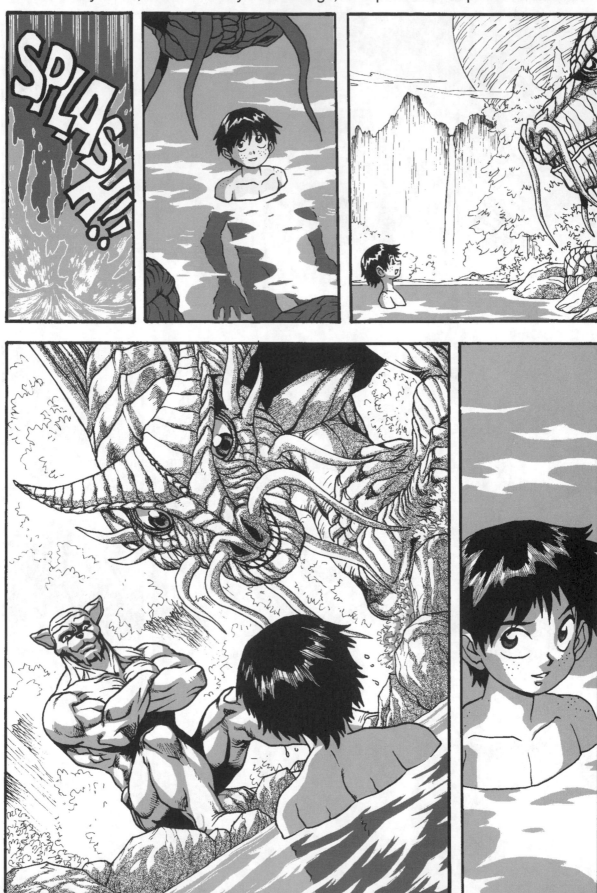

The last minor detail is to show water running down the wet character. This is very easy to do; just cut thin, white streams through the shadows. Do any more and you're trying too hard. This will get the idea across simply and cleanly. It does help to put the character in a lot of shadow if you plan to make them wet, so that there is more room to show and to place streaks of water.

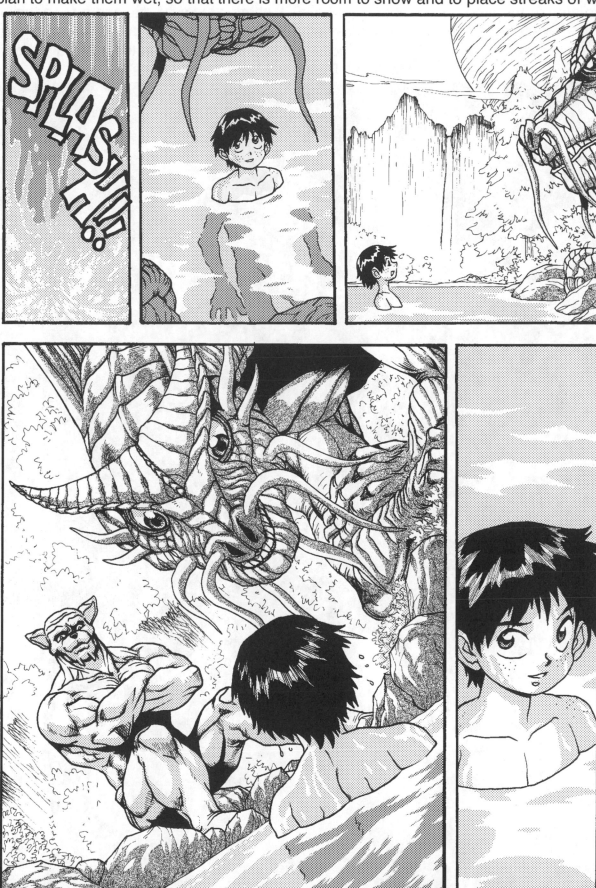

Lightning, very frightening!

Lightning and similar energy effects are fairly easy to create. You just make little arcs of pure white that go around the area you want them to be in. Lightning forks, twists, and turns seemingly at random, so almost any shape you create will work. Just try to keep the various arcs close to where you want the viewer's attention to go. If the sparks go too far in too many directions, it will be difficult to tell what the focus should be.

Notice in all of these examples that there are extreme darks around the lightning energy, This really helps to make it pop out and look bright. If you are doing a scene with a fairly heavy amount of special energy effects, you may want to use a darker base tone than usual.

When planned out, lightning and other bright energy effects can really strengthen the drama or impact of the scene.

On this page for example, I am given some art with light pencil marks indicating where effects could go, and the rest is left up to me.

I examine the image and notice the character in the second panel is shielding his eyes, indicating an extremely bright light. Once I realize that, all sorts of fun ideas come to mind that I could play with.

Figure A

In figure B, I start out by dropping in dark tone in places where I'm very confident it will be. I use my darkest tone of 50% grey, not intending to use anything lighter except maybe a texture for the dog's fur. However, I am not yet completely sure how light to make the tone, so I leave some of the brighter areas alone for now. If I change my mind later, I can always add a darker tone.

I am fairly confident, however, that I will only use the dark tone, so that the shades involved will be pure white, pure black, and dark grey. When surrounded by that much dark, the whites will seem extremely bright, almost glowing, and should pop out quite nicely.

Figure B

The first two panels go much the way I expected. I add some shadows to the large black dog and the kid, plus some effects details, but in the last panel, I decide to make the dog the complete focus and push the kid back. So I fill the panel with dark tone and cut away enough light so that the dog seems to be glowing, creating the light himself. I also use a light tone to detail the brightest areas of the dog in order to help contrast the variances in his fur better.

Here is where I finalize all the effects. I etch around the sources of light to give a proper glowing effect, and finish rendering the kid. I also decide to use a texture for the dark areas on the dog, not only to simulate fur, but to make him lighter and even more of a light source than before. Because the sequence is so stark in lights and shadows, it makes it seem like the light is extremely bright.

Fire, not that different from lightning

Well, I don't recommend trying to run your electronics on fire, but when it comes to toning, the techniques for rendering fire are not all that different from those for lightning or other energy.

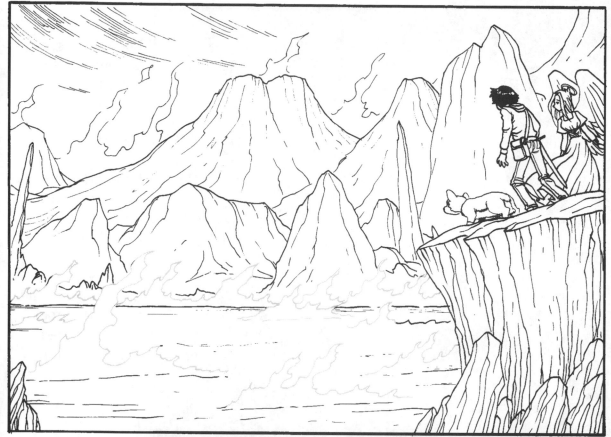

This is a fairly impressive-looking scene, and the obvious initial focus is the mountains surrounded by fire, rather than the characters looking at them.

I am going to leave the characters a stark mid grey tone to help keep them separate from everything else.

Figure A

The very first thing I do is drop down basic tones on the key elements. I separate the sky and foreground characters with a dark tone and leave the fiery area stark white.

The work on the characters is done, the attention is going to be on the background from here on.

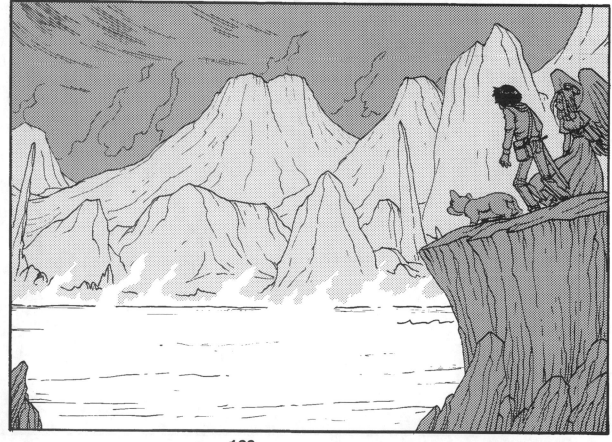

Figure B

This panel starts to come together very quickly. With the characters serving as a framing element by being dark, the viewer's attention is drawn straight to the burning mountains. I realize shortly, however, that the ground could not be a pure fire-white all throughout, and so I go in and add a light tone to the ground.

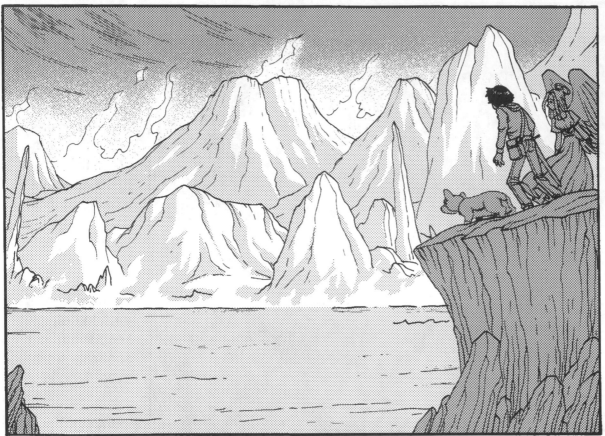

I start by etching a glow effect into the background fire and lighting up the mountains.

I try and light only one side of the mountains despite the fire all around, since if they were lit on all sides, it would become harder to make out their shape and form.

Figure C

Here I etch in the remaining glows and effects, returning the bottom area very nearly to its all-white look from before, with just enough light tone to show off the effects and details of the fire.

Figure D

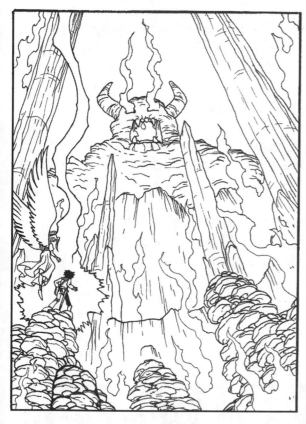

Here is another example with both fire AND lightning, where most of the same ideas apply, but the layout of the image presents unique problems. Attention needs to be drawn to the characters, the lightning bolt, and the scary face in the mountain, while applying special effects throughout the image.

I start by once again separating everything, making the foreground and sky both a mid grey tone and leaving the rest a light grey. I intend to put a lot of light into the sky, so I'm not worried about there being a conflict.

Unlike in the previous example, I do not give the flames or lightning any special treatment. Instead, I make them a flat tone like everything else, so I can better judge how the foreground looks as a stark, dark tone.

This way, I can better determine how much light should be given off by all the effects while still keeping the focus points.

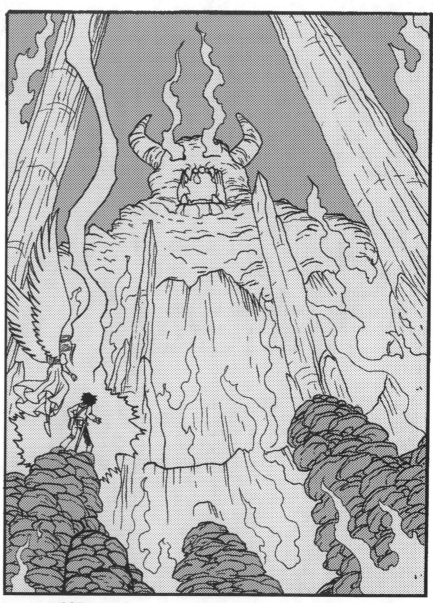

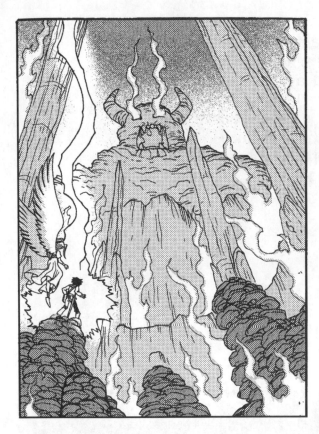

I go through and make all the special effects white, but make an effort to distinguish the fire and lightning.

For the fire, I leave a small bit of grey around the edges to give it some mild appearance of depth.

The lightning I make stark white and give a great deal of glow, and I heavily light up the characters in order to try and make them pop out more.

At this point, I also etch a glowing effect into the sky to help separate and push that back, as well as distinguish it from the foreground.

To pull it all together, I add mild glows along the bottom of each cliffside. This helps separate each of the three planes while still using only the one tone and creates the ambiance of fire lighting everything.

I also make a few mild areas of white on the rocks around the characters, again to help pop them out more. With this effect around just them, it serves as a spotlight. Had highlights been placed on all the rock texture, the entire panel would have been a difficult-to-look-at mess, and the focus would have been lost.

126

CHAPTER FIVE: Start to Finish

In this final chapter, you'll see a very different set of pages, done start to finish, that utilize just about everything that has been taught so far. Observe the process and how all the lessons are applied in different situations, then give it a try on your own stuff!

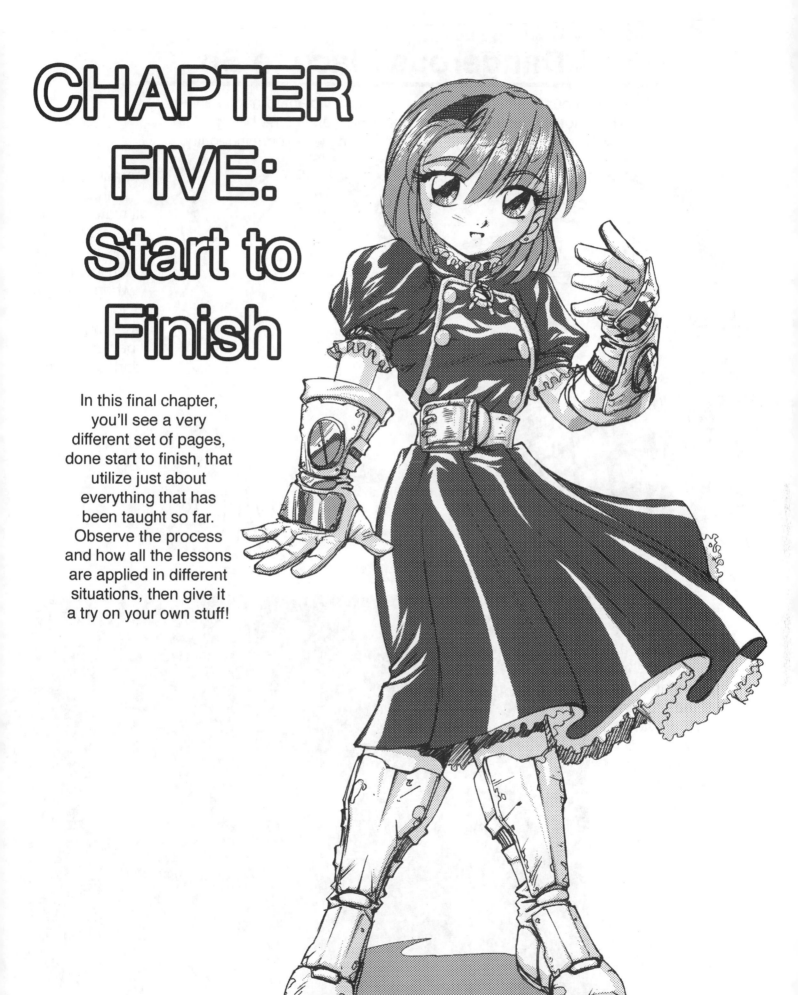

A Dangerous Place to Be

The first of our last two examples is part of a violent tornado sequence. This shot will require the use of a great many of the background techniques shown up to this point, along with some ingenuity.

Tornados are the pinnacle, the ultimate version of a nasty storm. This should be taken into account when toning a tornado. It's probably going to be very cloudy, dark and stormy.

Figure A

The very first step, as seen in Figure B, is to place a pair of grads to separate the sky and the ground. This will provide an element that will tie the whole piece together and that could not be easily replicated later in the process.

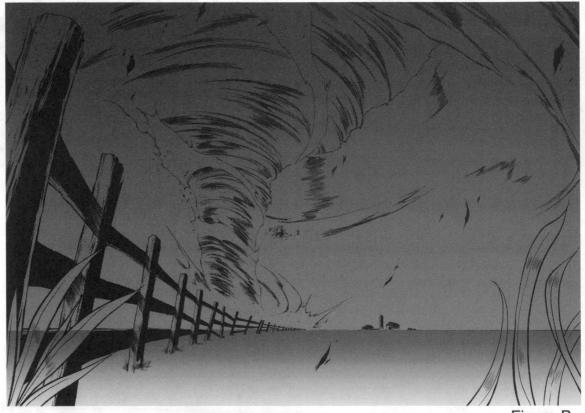

Figure B

With the early planning and base elements of the image done, it is time to start fleshing out all of the individual elements. A great number of different effects are going to be used from here on, so pay attention and compare the images closely to see the differences between steps. Most of the background effects will be done first, because the foreground elements will later cover things up, and it's easier to work over an element than around it.

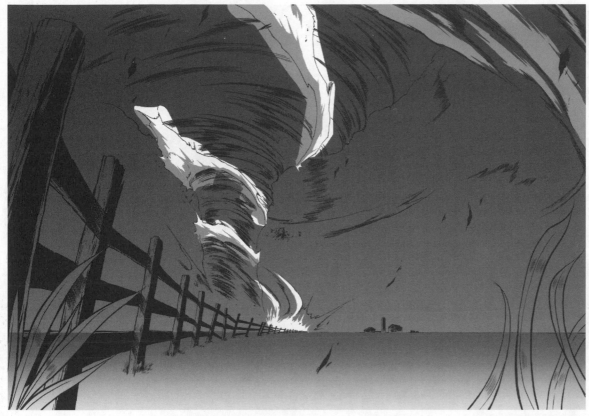

In Figure C, I start doing the early light effects from the tornado's motion. This is the same idea as basic clouds, only with more defined edges to match the line art and demonstrate motion.

I don't try too hard to stay inside the lines, because the very next step will cover up the excess.

Figure C

With the first bit of effects done, I then add a flat layer of tone over the tornado shape as seen in Figure D. See how the flat tone covers the excess from the previous effects?

When you can save time and effort, try and do so!

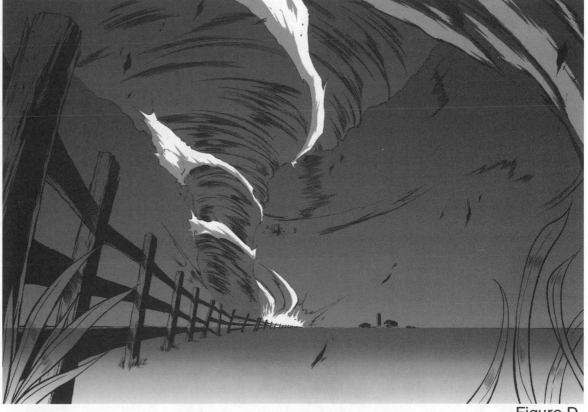

Figure D

The many elements are slowly starting to come together, and the image is starting to look more and more like a dark and cloudy sky. The "Dramatic Clouds" lessons are starting to come into play, even though the full details on them won't be done until late in the process. The point right now is still just trying to establish an overall feel to the piece and to get all the elements into place.

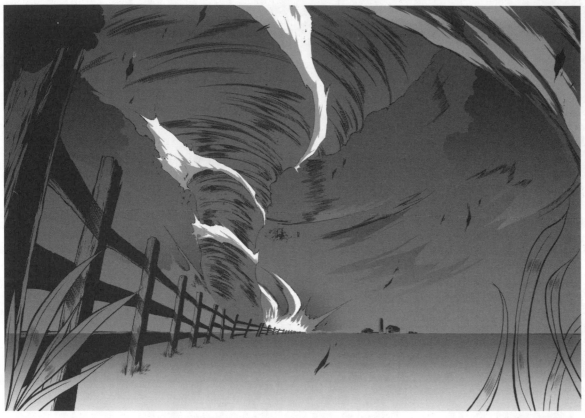

Here I apply cloud shapes in the background. Their shape is actually specific, as they are being twisted and pulled toward the base of the tornado.

Combined with the light set of clouds in the upper right foreground, they're starting to create a sense of depth.

Figure E

In Figure F, I finally place down tones on the foreground fencepost and grass. I use fairly dark tones to help separate the elements from the light grad.

Also, there is going to be white etching in the final piece, and I really want the light areas to stand out sharply.

Figure F

130

Now, with all the basic foundation tonework done, comes the time to start etching out the white areas and giving texture to everything. Notice the different sizes of strokes and textures created all over the piece. The fence post, the grass, the foreground plants, the tornado, and the different sets of clouds all have unique and different textures being applied. This keeps the image interesting throughout.

The the layering of elements is giving definition and highlights to the whole. Because there was such a wide variety of tones and a grad put down initially, the entire etching process is simple and involves only using white. Had there been less variety in the base toning, this part of the process would probably be trickier and involve trying to apply multiple extra light tones, instead of just scratching in the white.

Here is the final product. I put a little more effort into adding white highlights, mostly on the clouds. The entire image now has a sense of strong wind forcing things all around to move. The consistent use of white down the center of the tornado, surrounded by darks on all sides, helps draw attention right to the tornado, even though it is not perfectly in the center of the page. All in all, the final composition is strong and succeeds in giving off the ominous air of a stormy sky.

And now for a friendlier sky!

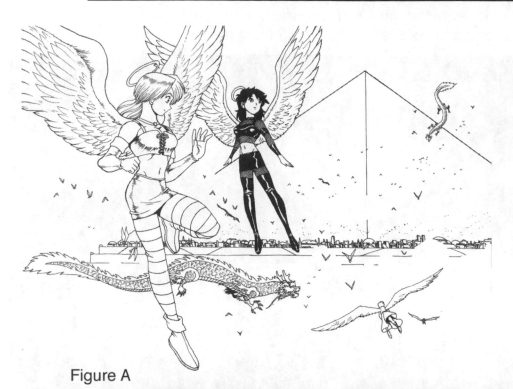

Figure A

For our last example in this book, we're going to look at a complicated scene set in the clouds that involves characters.

The first step in Figure B is, as always, placing down basic tone on key elements. I'm going to keep to the rule of two tones here for most of the page, the sole exception being the far background, in order to help better separate all the other tones that will be on the page.

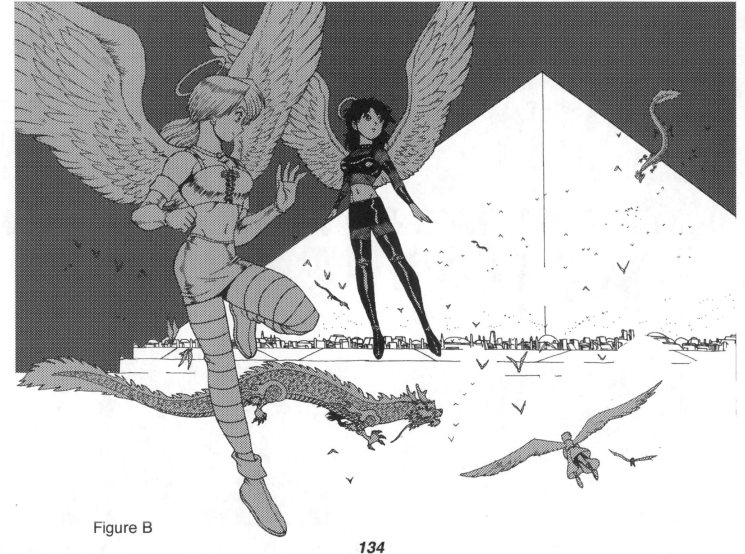

Figure B

The artist indicated in light pencil a large number of clouds, so this piece is going to have a lot of clouds by the time it is done. I'm only going to use basic clouds, so that the characters can remain the focal point. I start by removing areas of the background, because it is the only tone that has really been dropped in at this point. I also create a sun flaring brightly, so that I establish a light source and give the background a little variety it wouldn't have with just clouds.

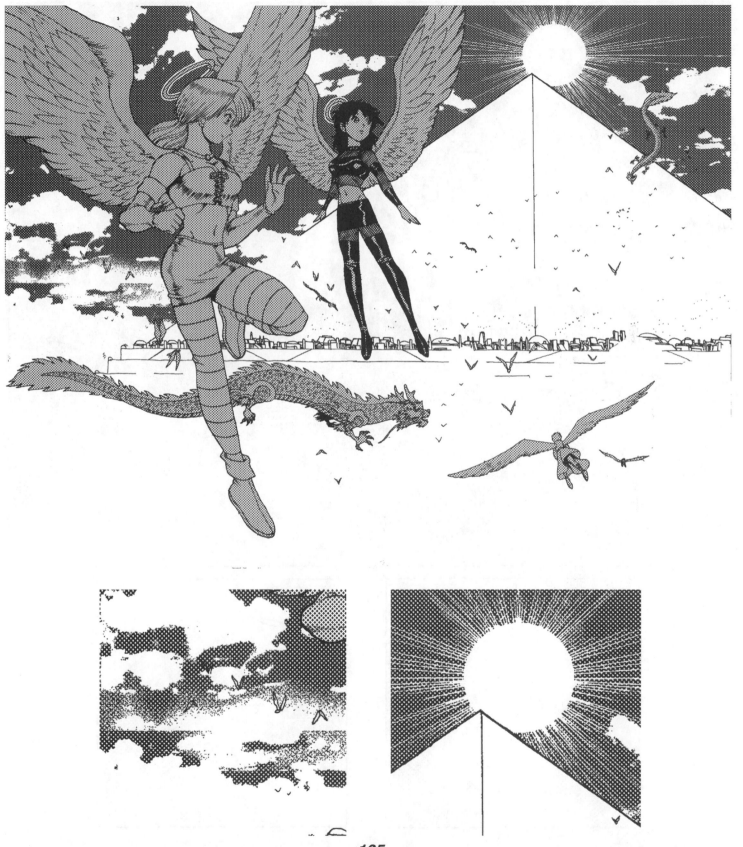

I now go in and do the second step in creating basic clouds, and place down light tone in fluffy spots where the shadows of clouds would be. This is fairly random, and I make up each cloud as I go. The main objective is just to fill the page with clouds and to have them be light enough that they aren't at all detracting from the characters. Ideally, the viewers will just gloss over the clouds, but if they stop and look, there will be detail there to appreciate. I also give the giant pyramid a shadow, using the mid grey tone, to help it stand out without being intrusive.

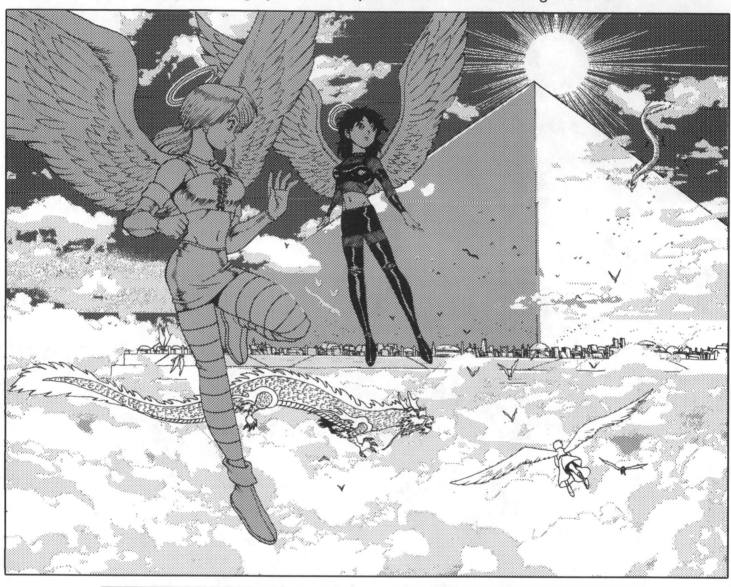

Here I start to do the character rendering. Because I applied the mid grey tone to them, I cut away everywhere that isn't going to be that tone. Shadows on the clothes and the darkest wing shadows remain.

If you remember the front girl's image from the start of the book in the "Tone Choices" lesson, it should be obvious how I am going to tone this particular character.

Next I go in and apply the light grey tones to the characters. With the background so well established at this point and the light source being plainly visible, I have a pretty good idea of how much light and shadow the characters require and tone them accordingly.

I don't put as much detail into the character further back, because the detail would be lost, and because when something is further back, it should be toned more simply.

Reaching the home stretch, I add highlights and secondary tones to the characters really far in the background. They are tiny, so I keep it really simple. I use the mid grey tone on them to help pop them out from light grey cloud shadows. Again, I put less toning detail into them, because they are not up close in the foreground.

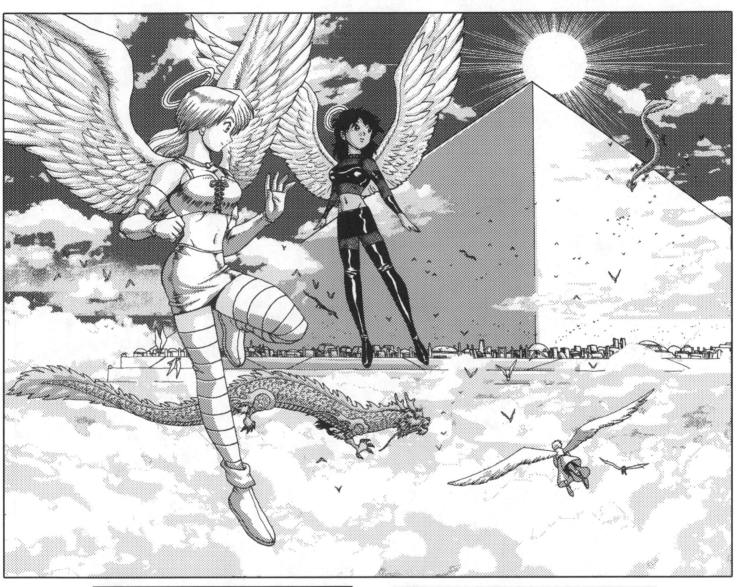

Finally, I take in the image as a whole and go in to add last-minute details: little spots of dark tone in some places, tone cut away to add more white in other areas to smooth some things out. And the piece is finished!

Now go and practice all these toning techniques yourself and master them! And remember the most important thing of all: HAVE FUN!